A LIGHT TOUCH
PAINTING LANDSCAPES
IN OILS

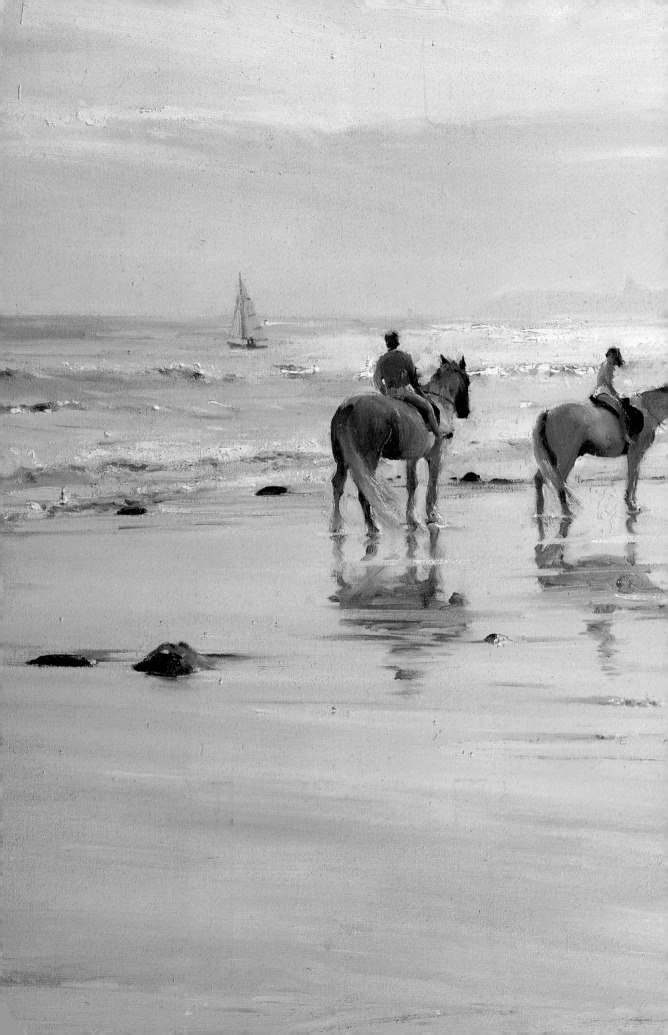

A LIGHT TOUCH

PAINTING LANDSCAPES IN OILS

DAVID CURTIS

David & Charles

A DAVID & CHARLES BOOK

Copyright © David Curtis 1994
First published 1994
First paperback edition 1997

A catalogue record for this book is available from the British Library.

ISBN 0 7153 0623 5

Typeset by ABM Typographics Limited Hull
and printed in HONG KONG by WING KING TONG Co LTD.
for David & Charles
Brunel House Newton Abbot Devon

ACKNOWLEDGEMENTS

I would like to thank my editor, Alison Elks, for her invaluable help
and advice; Richard Hagen, for his support and encouragement
over the years, and for the loan of transparencies; Roland Colcutt
and Bill Mycock, for their excellent colour photography; Trevor
Chamberlain, for his foreword; Anne and Cliff Rowe, for typing
and recording the manuscript – and managing to read my
handwriting; Arthur Begg, for his framing facilities, and finally
Andy Espin-Hempsall, for painting with me in those early,
formative years.

ARTIST'S NOTE

Each of the step-by-step demonstrations in this book, apart from
Art in Action, was painted *plein air*. The light changes which
naturally occur whilst painting outdoors are reflected strongly in the
photographs of some of the images; I hope the reader will
accommodate these unavoidable variations.

CONTENTS

DEDICATION

To my family, friends and painting companions
and in memory of David Noble

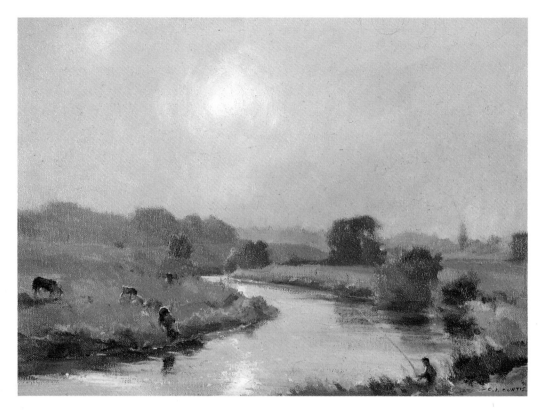

THE RIVER IDLE AT NEWINGTON
Oil on board, 14×10in (35×25cm)

FOREWORD

It gives me great pleasure to write this foreword to David Curtis's book on oil painting, as I have enormous admiration for his work.

He – like me – is a strong advocate of working on site, in all weathers, observing and capturing the transient conditions and effects. He is not content merely to work cosily in the studio, relying heavily on the use of photographs, clichés or formulas, but is always seeking anew the subtle changes prevailing from subject to subject. I have painted with him many times, witnessing his seriousness of approach and intensity of working.

He favours strong compositional and design elements in his pictures, very often exploiting the dramatic impact of painting directly into the light, always with an underlying sense of sound draughtsmanship, and frequently displaying an overall light, airy feeling. Nevertheless, he is also a master of the flat light which is so often experienced in his native Yorkshire. Figures, too, feature prominently in many of his compositions. In addition to landscape, David finds great satisfaction in painting quite complex barn and workshop interiors, and always with a studied skill that transforms cluttered jumbles into well-considered arrangements.

The reproductions of paintings throughout this book are a joy to the eye and, together with the informative text, cannot fail both to instruct and inspire.

TREVOR CHAMBERLAIN ROI, RSMA

INTRODUCTION

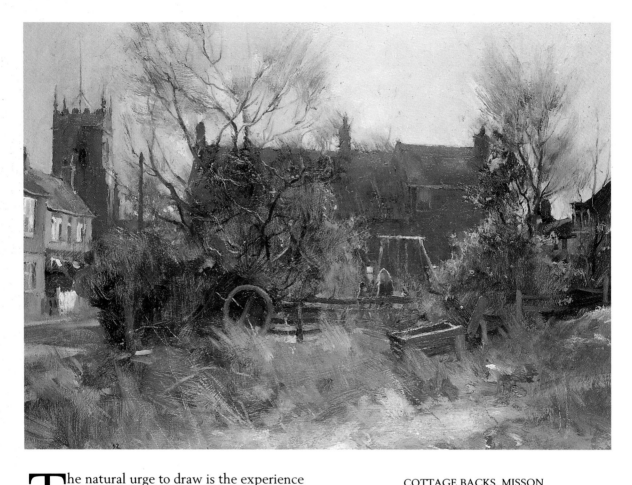

COTTAGE BACKS, MISSON
Oil on board, 16×12in (39×30cm)

The natural urge to draw is the experience of all children, long before the various taught disciplines are instilled by their elders. For many, the joy of drawing and painting is soon discarded in favour of other activities, and many only resurface later in life. These individuals make up a good proportion of art societies' and painting class numbers, and many a formidable latent talent can be discovered amongst their ranks.

I recall, in my early years, that quality of membership in my local art group and others in the region. Organised painting venues were available throughout the summer, with guest tutors of high calibre in attendance. Those fine *plein air* painters of the day, Edward Wesson,

Jack Merriott and R.O. Dunlop, amongst others, spent their summer weekends touring the art societies, and the presence of these 'figureheads' gave the weekends a real sense of occasion and purpose. I look back with great fondness to that time.

We experimented in all media, nearly always out of doors, and in all weathers, wrestling with the subtleties of pure watercolour, gouache, the 'Flo-master' pen and wash technique and, of course, oils. The essentials of composition, tone and colour, in that order of priority, were held as

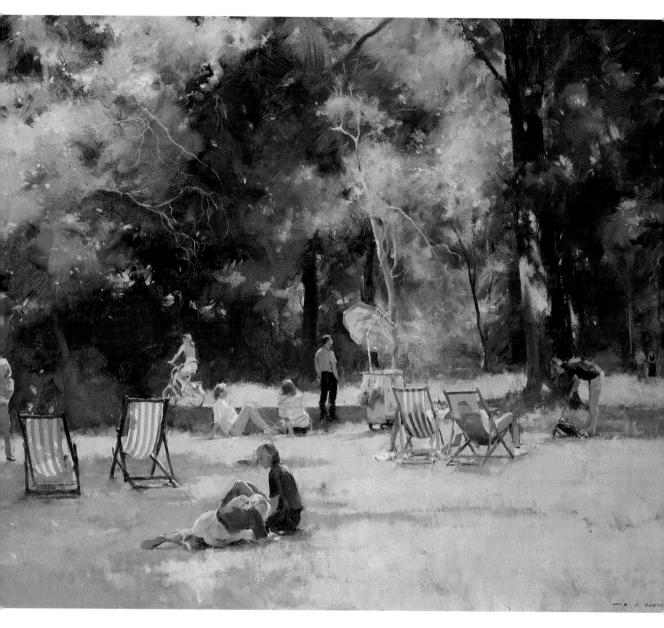

THE ICE-CREAM SELLER
Oil on canvas, 30×24in (74×60cm)
This park scene is composed of a series of little cameos all brought together to produce a 'set piece' composition. Although a studio undertaking, large areas of loose brushwork lend a feel for the work having been produced plein air. It is hoped that the painting exudes a feel of calm and tranquillity in an otherwise hectic world.

parameters at all times. Few could afford expensive studio locations, the dining-room table being the essential prerequisite for finishing off work done on the painting day.

Those formative years yielded a formidable output of work, mostly experimental and more often that not quite disastrous in terms of end result, but occasionally a milestone was reached. I recall one such occasion, when painting foxgloves in a woodland setting with a friend. Selecting a small part of the whole landscape, we wrestled with the close tones offered to us by the pattern of the subtle greens and pink-purples, unsure as to the accuracy of our applied mixes. Taking a break from our endeavours, we walked a short distance away to view the results. The canvases merged with the surroundings, leaving only the easel legs plainly noticeable, and we knew we had reached a little way into the understanding of tonal value relative to the oil-painting technique.

This long apprenticeship with the intense *plein air* painting experience, coupled with

SNOWSTORM '91
Oil on board, 10×12in (25×30cm)

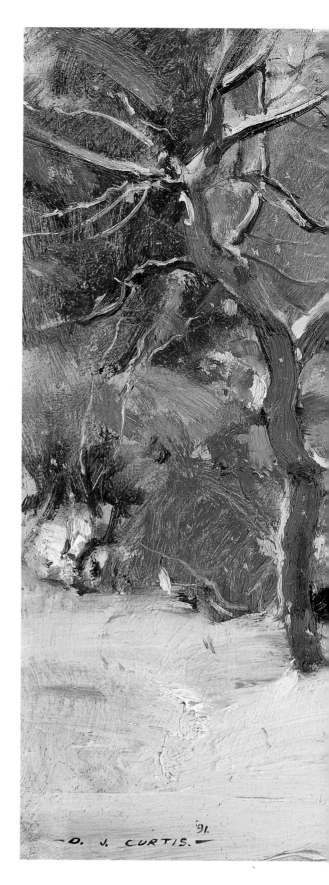

concentrated drawing practice at any spare moment of anything and everything, shaped a lifestyle then and remains my prime motive force to this present day.

While in essence the scope for landscape material should be limitless, it is often commented by painters that the search for subject matter is becoming increasingly difficult. Long gone are the set-piece subjects of rustic charm, so often replaced now by modernity of far less appeal. So, while the pure landscape still remains fairly intact in a broad sense, it is becoming more difficult to find visually interesting features within it. This may, of course, not be altogether a bad thing. It forces us to paint the landscape 'warts and all', and so identifies our work, whether attractive or otherwise, as being of our time.

When viewing exhibitions by societies, both local and national, this is amply illustrated. I see a move towards the landscape viewed more locally: the garden theme, for instance, abounds – almost an outdoor still life. The use of 'close-up' figurative content within this format puts greater demands on the painter's skill, and intensifies the need to maintain basic drawing skills.

There is also bold use of colour and the observance of simplified form to yield good design and pattern, often with the subject matter extracted and only a tenuous link with the original observed information remaining. With the mix of the traditional and the more progressive approach apparent on our gallery walls, there should be much to motivate both the professional and the ever-increasing band of amateur painters of today.

The painter can be described as a component in the communication system providing a link between the subject (or idea) and the canvas. If we push this a bit further, and regard the completed painting as a sort of transmitter and the viewer as the receiver, we can see that this system will only work so long as both ends are 'switched on'. If the system fails, can it be the fault of the painting, when we have done all we can to get tones, shapes and colour right? In themselves, these may be all we want them to be, but alone they are somehow not sufficient for the painting to do its job. The visual world has everything going for it – it has light of subtle and varying degrees and, above all, it has three dimensions. Our painting certainly has light

MOORINGS ON THE DORDOGNE
Oil on board, 10×12in (25×30cm)

which falls across its surface, but only an illusion of light within it, and although it has two dimensions (height and width), the third dimension (depth) is yet another illusion created by the skill of the painter.

Fair enough – but why does the system sometimes fail? Could it be the sensitivity of the viewer? Perhaps, but that is conjecture, and not our prime concern as painters. Somehow we have to see to it that the painting is effective in every way as a transmitter and that both ends of the system are 'switched on'. This means that within the limits of the canvas area we must make sure that what we do is so organised/constructed/composed that it is of immediate appeal to our observer.

Painters are no different to other folk in that not everything we do is successful. Sometimes it is because we have overdone things when an understatement could have given the viewer a chance to participate – we have 'done all the

talking'. Even worse, there are times when we just can't find out why the painting does not evoke a response from our audience. Let us imagine we can undo things – work backwards, so to speak. We can remove the colour and still have a satisfactory design in monochrome and pleasing arrangements of tonal masses. We remove the tones, and are finally left with an arrangement of linear shapes (the lines which bounded the tonal masses). We are down to the basic skeleton of the picture and can see that however good the picture may be in other respects, if the linear arrangement is weak, then the picture is weak.

The aim of this book is to examine the principles behind producing landscape paintings in oils by exploring everything from selecting a subject, through composition, colour and tone, to all facets of the painting technique itself. The essential experience of working in all media, and the switch from one to the other, is an important

POPLARS IN A BREEZE, DORDOGNE VALLEY
Oil on board, 20×24in (49×60cm)

AUGUST AFTERNOON, SLAYNES LANE
Oil on canvas, 14×10in (35×25cm)

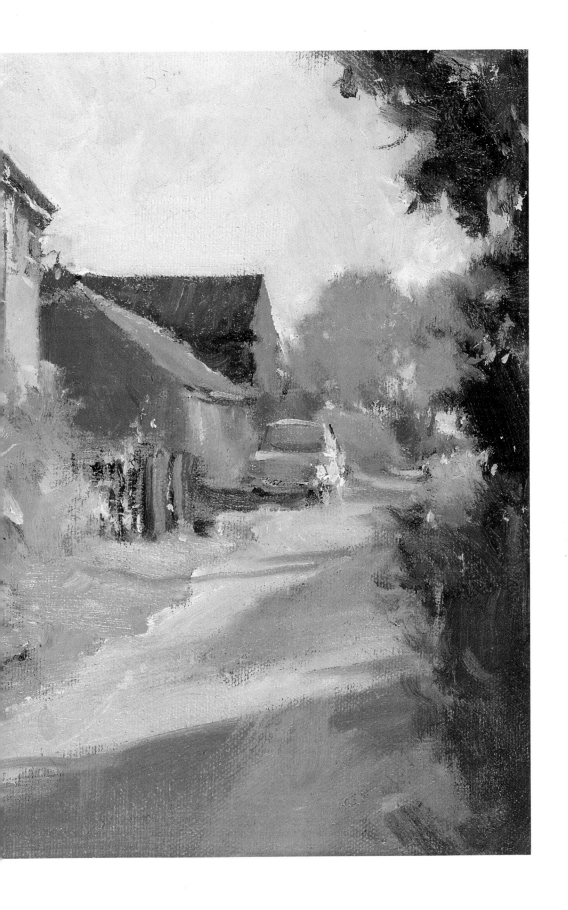

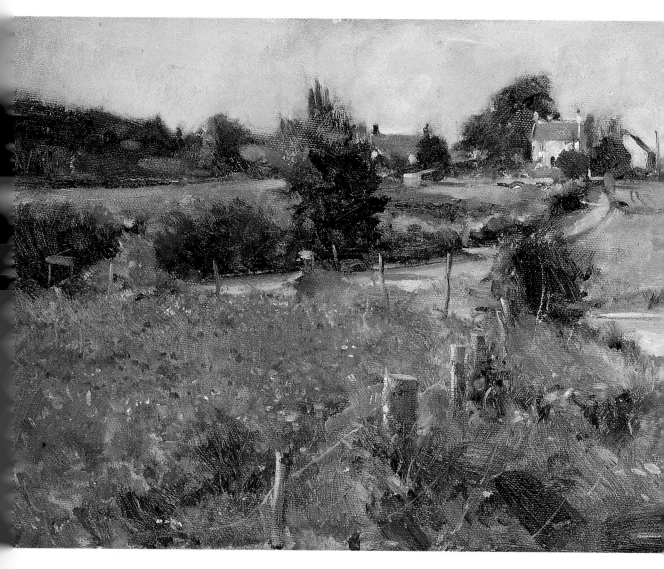

A POPPY FIELD AT HARWELL
Oil on canvas, 14×10in (35×25cm)

stimulus for hand and eye. Expertise in both watercolour and oils offers a depth of vision and increases one's scope for potential subject matter, as well as the ability to deal with light effects and atmosphere. Indeed, some subjects lend themselves to watercolour and others clearly to the oil technique.

It has long been the opinion of painters that an hour's painting 'in the field' yields greater effectiveness than several hours of studio painting away from the subject, and I would wholeheartedly endorse this view. To be 'fired' by the subject, and experience the urgency of getting to grips with all the factors of basic composition, design, tone and colour on site heightens the senses and, whatever ensues on canvas, at least the result is likely to be lively, and will not appear too finished or considered. Little areas of abstraction and understatement which are left for the observer's eye to resolve are features that make a

painting endure, and ask more of the audience than the over-finished piece of work. To illustrate this principle, at the end of each chapter I have provided step-by-step demonstrations, which I hope will set some guidelines for the outdoor painter.

More often than not, the immediate appeal of a particular subject is governed by a special light effect at the time of viewing. It follows, therefore, that the same subject can have different degrees of appeal according to the changing light conditions. It is then the duty of the artist to search for that effect which so enhances the composition offered by the subject, that it makes the apparently ordinary subject appear extraordinary.

A sound guide for the painter has always

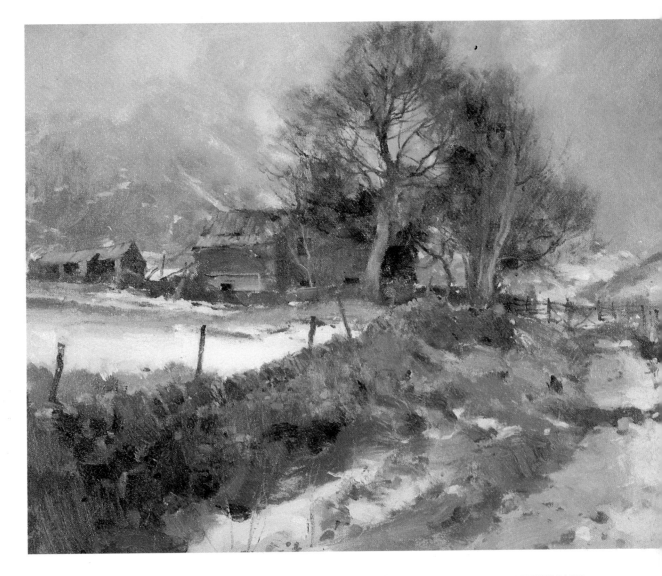

SLEET AND SNOW, ABOVE HATHERSAGE
Oil on canvas, 20×16in (49×39cm)

been to paint early and late in the day. This maximises shadow length and intensity of colour, along with tonal response and depth. The mood and atmosphere of the subject matter also intensifies with these extremes.

Probably the greatest challenge, however, is to paint directly into the light. Not only does this simplify form, it also challenges the artist towards effects no other light conditions can generate. The resulting appeal to the observer is immediate and stunning – dark areas are intense, while the purity of the lit areas has to be absolute. Coupled with good design and arrangement of the forms within the canvas, these elements can lead to the most memorable work the painter can produce – not only does the subject itself become extremely intense, but usually the consequent desire to paint also intensifies accordingly.

Varying degrees of light availability and the

elements of the particular location can offer continuous scope for effect. For example, for me, the English coastal light offers a subdued, milky effect which is useful when dealing with the wet, mirrored effects of the receding tide. By contrast, the sharp west-coast light of Scotland suggests the use of a totally different palette. The excitement of the move from one area to the other is an important stimulus for the painter's eye.

I would carry the theme of light into all painting locations. Interiors, with the light streaming through windows, and cracks in barn roofs; the dappled light playing on figures in woodland; the significance of light on the intimate still-life subject – the scope is endless, the need to maximise its effect on our work a basic essential.

CHAPTER ONE

MATERIALS

Some painters place great importance on the purchase of as much 'gear' as possible, and then on the fastidious care and attention which they lavish upon their brushes and paints. For me, on the other hand, the materials are merely necessary tools of the trade and, I fear, I treat them with abject disrespect! In the intensity of the painting experience, I often lose paint-tube caps and allow the palette to build up so much surface paint that after a while it resembles a mountainous relief map – not to mention the less than charmed life experienced by my brushes.

The ideal lies between these two extremes. After some time as a painter, of course, materials choice does become a very personal and important factor, and eventually these choices become the trademark of the individual.

THE CANVAS OR BOARD

Let us look first at that surface which is at the receiving end of all our visual feelings and emotions – the canvas or prepared board. Here there is a wealth of choice of both prepared surfaces and the proprietary materials available to produce one's own chosen surface. Try everything: eventually you will find a surface which really suits your own feel for the medium. I tend to prefer a slightly textured, dryish surface, but find that different subjects might require a surface modified to some degree from that which I would normally use.

BOARD

For outdoor work on a small scale, and especially if you are travelling, a Gesso/texture-paste primed hardboard surface is ideal. For a size range from, say, 10×7in (25×17cm) up to 16×12in (39×30cm), choose the sheet of minimum thickness: 1/10in (3mm). For larger sizes, you will need to use a hardboard sheet of more standard thickness for its greater rigidity.

Taking the smooth side (the rough side tends to have rather a mechanical grain effect), coat the surface with a proprietary acrylic primer and leave to dry. Then apply one coat of Gesso primer and texture paste, mixed in equal proportions, and again leave to dry. If a slightly rougher surface is preferred, increase the volume of texture paste. Bear in mind, however, that the rougher the surface of the board becomes, the greater the wear on the brushes. Finally, apply a further coat of the Gesso primer only to achieve a dense, white finish. The net result of this preparation is a board surface not overly porous but with a little 'tooth', and adjusted to suit the individual's preference.

Once fully dry, give the complete surface a wash of neutral colour – french ultramarine and raw sienna, with turps only – applied in the same way as a watercolour wash. The purpose of this is to eradicate the 'frightening' white surface, and at the same time create a tonal unity to all subsequent brushwork.

It is worth producing these boards in some quantity. I would normally have ten of each made up in the following sizes: 10×7in (25×17cm), 10×12in (25×30cm), 14×10in (35×25in) and 16×12in (39×30cm). Each board is given a wash, some in a cool, neutral mix of tone using french ultramarine and raw sienna, through to some with a warmer hint using french ultramarine, raw sienna and burnt sienna. This system allows scope for choice on site, when faced with the variations of cool and warm subject tendency.

Not all subjects, however, will lend themselves to a fixed-tone surface. An alternative method of expression can be achieved with the wash applied on site as the first stage of the painting, employing a 'rub-out' technique. This uses a rag to wipe out sections of the composition, so suggesting the lightest tonal areas. These then relate to, say, the mid tones of the remainder of the subject (the mid tone being the initial applied wash), thus achieving unity in a rather different

STRETCHING CANVAS

STAGE 1
Assemble materials – stretcher pieces, wedges, copper tacks and canvas piece, suitably oversize by about 50mm per side.

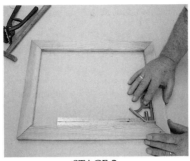

STAGE 2
Assemble stretcher pieces, ensuring the final frame is perfectly square.

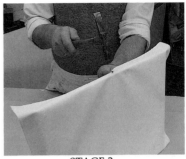

STAGE 3
Lay the canvas piece over the stretcher assembly and secure with preliminary edge tacks on the centre point of each side.

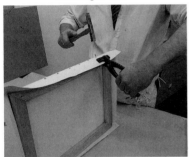

STAGE 4
Using canvas-stretching pliers, position further tacks at about 50mm spacings, working outwards from the centre on all four sides to within about 50mm of each corner point. Secure opposing sides in sequence.

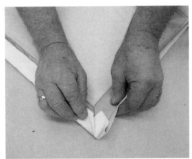

STAGE 5
Carefully wrap around each corner of the canvas as shown, and provide further tacks to within 25mm of each edge.

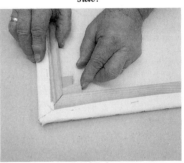

STAGE 6
Staple intermittently along all sides of the reverse edge, particularly at the corners. Position the corner wedges and tap out gently with a light hammer, using a diagonal corner sequence.

manner. The step-by-step demonstration on pages 26–30 outlines this approach in detail.

This board system is of great benefit when travelling. The boards can be stacked neatly, and if the thinnest type is chosen, offer a lightweight package for the traveller. This is all very well, you may think, for the outward journey, but what about the return, with half a dozen or so wet oil paintings to transport? The best solution to this problem is the strategic use of one or two tubes of quick-drying 'Alkyd' colours – certainly the most frequently used titanium white body colour, and maybe ceruleum blue and raw sienna. These mix well with the parent oil colour and will normally render the finished painting touch-dry in two to three days.

CANVAS-COVERED BOARD
It can be argued that nothing really beats a true canvas-grain surface. The ready-made canvas-covered boards available from all artists' supply outlets are ideal. I use these often for outdoor

work on a scale larger than 16×12in (39×30cm). Though by no means necessary, I like to apply a further coat of oil-based primer to give a little extra 'dryness' to the surface feel.

Distortion can occur with excessive dampness or heat and is a very definite drawback with this type of painting surface. Diagonal crosses of masking tape placed corner to corner on the back of the board can help to alleviate the problem.

STRETCHED CANVAS
There is nothing that can quite compare, though, with the feel of a stretched canvas – that lovely 'sprung' feel as the brushwork is applied is an experience all of its own. For painting trips away, storage and possible puncture damage are factors to consider, but I always like to have at least one or two canvases on hand, come what may. For studio work, on both a small and large scale, I would recommend their use: a smoother-grain canvas for portrait work, and a medium cotton grain for other work, including landscapes.

A wide range of ready-made sizes is available, although the cost may inhibit the amateur. A longer-term but more economic alternative is to buy canvas by the roll, taking care to choose a grain which you like and are familiar with, otherwise there is always the chance of being stuck with a large quantity of canvas you may never get round to using. Do bear in mind that a certain level of skill is required to produce a successful stretched canvas. The sequence of operations is illustrated on page 19.

As with canvas-covered boards, once the canvas has been stretched I would add a further coat of oil-painting primer, which can be either oil- or acrylic-based. There is a ground rule to be remembered here, which states that oil can be applied over acrylic, but never the reverse. This is because acrylic-based products will not 'key' into a previously applied oil-based surface, so if an acrylic primer is used as a covering over, say, an old or unsuccessful oil painting in order to reclaim the canvas or board, there is a strong likelihood of the whole painting surface peeling off completely!

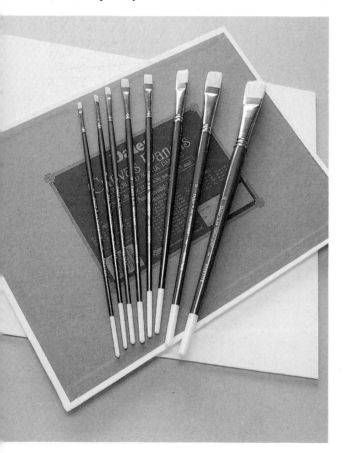

A selection of oil painting brushes and canvas-covered boards.

BRUSHES

The next link between the painter's vision of the subject and the carefully chosen surface is very much a matter of familiarity, experience and personal choice. Brush, palette-knife and the end of the finger are all expressive tools, the first in the list having by far the shortest life span! Rough painting surfaces and lack of care take a speedy toll on the life expectancy of brushes and I generally regard them as items with a relatively limited shelf-life.

There are three main shapes available – round, 'filbert' and flat – and these are then sub-divided into long and short point lengths. Experience usually determines preference, but for controllability in the field and a reasonable life span the short, flat type is a good choice. The original shape is retained quite well even with heavy use and a little edge wear can give the brush a modified filbert shape, so useful on a smaller scale for finer strokes.

I always choose the smaller No 1 and No 2 bristle brushes with a particularly tightly crimped ferrule. These seem to contain the individual bristles more effectively and, through wear, can offer a beneficial 'knife-edge' effect when the brush is applied in a side action, acting as a most effective tool for those more finite passages.

With regard to care, a good soak in a jar of turps, followed by a thorough scrub on an absorbent rag, is usually quite sufficient to wash away oil pigment. The use of detergents or soap as an afterwash tends to soften the bristles so that, even when dry, some of the spring in the brush is lost.

In general, the life expectancy of brushes is directly commensurate with the volume of work produced and the choice of painting surface – the greater the 'tooth', the heavier the wear.

PAINT

No painting generation has enjoyed a greater choice of prepared quality materials than those working today. From the student-quality paints through to the finely ground, pure artist-quality pigments, a vast range of colours is available to tempt the eye.

It follows that there is a temptation to select far more than might reasonably suit the individual, and some form of discipline is in order to ensure that a sensible choice is made. In fact, a more restrained palette can produce a more con-

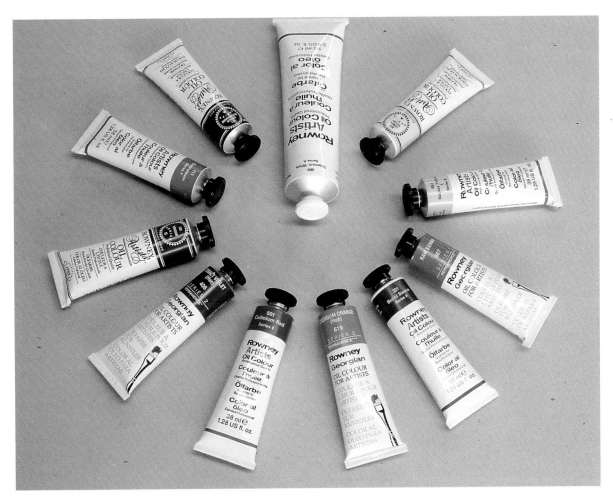

*A restrained palette can produce a more successful result.
The colours shown here, and listed below, make a very
suitable landscape palette for any painter.*

sidered and successful result than the kaleidoscope of colours often seen on the student's palette. All the colours on offer have a place, but you should select those which suit your style and purpose of work.

Bearing this in mind, I have suggested below a group of colours which may suit both the beginner and more advanced painter. So often one sees hard-edged, sharp-contrast results with what appear to be 'dead' dark passages, obviously employing prussian blue and burnt umber or an equivalent strong dye-based colour. These 'danger' colours are really a no-go area for the beginner, although they have a place in the more advanced painter's palette. Nevertheless, I do feel that a quieter palette offers more scope for controlled performance than strong, insistent colours which, even when mixed sparingly, tend to permeate the mix and so become uncontrollable.

Here is my suggestion for a landscape palette:

titanium white	Naples yellow
Winsor lemon yellow	raw sienna
burnt sienna	cadmium red
cadmium orange	cobalt violet
viridian	french ultramarine
ceruleum blue	

You will notice that some earth colours and blue-blacks are absent from the list. The application of burnt umber, raw umber, prussian blue and Payne's grey within a mix, unless carefully controlled, can lead to a dull, lifeless offering on the canvas, whereas the less intense choice can give scope for wonderful subtlety when the occasion allows. I would stress again that this thinking is, of course, purely personal and is by no means a ground rule for every painter.

Let us now look more closely at the characteristics of each of these colours.

Titanium white This is a good, dense white blessed with excellent covering power for large

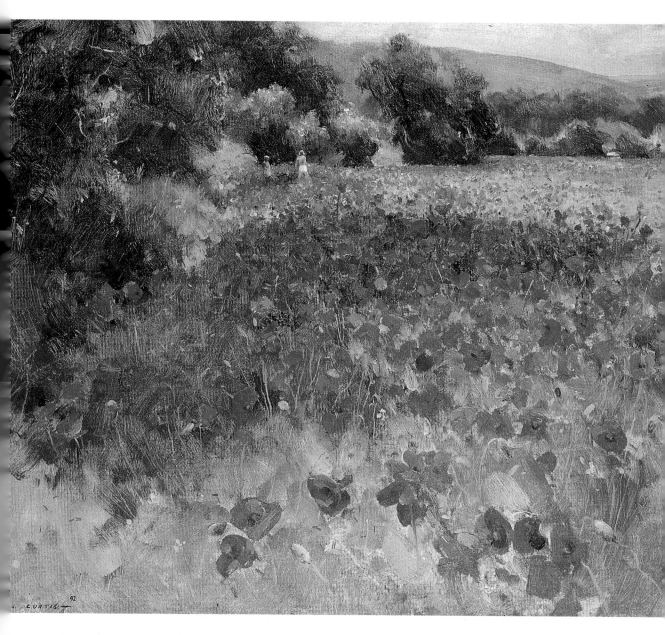

POPPIES, OLD DENABY INGS
Oil on board, 16×20in (39×49cm)
Produced entirely on site, in the same time period over two days, this interpretation of a field of poppies deals primarily with the variable effect of shadow and sun on the colour value and balance of this particularly intense population in a corner of a field. To stand for hours amidst all that colour, and sense the buzz of incessant insect life on a hot summer day, was a very heady experience indeed.

masses, making it ideal for the outdoor landscape painter. Flake and zinc white do not perhaps have quite the same covering potential.

Naples yellow A most useful gentle base colour, used to lighten a mix of colour when a semblance of warmth is required, and delightful when used with ceruleum blue as a subtle blue-green. Mixed with cobalt violet, it produces a useful warm purple for some mid-distance tonal passages in the landscape.

Winsor lemon A pure, vibrant bright yellow. Amongst its many uses it can be employed in conjunction with viridian and white for those brightest summer-sunlit greens, the mix then being tempered with raw sienna and ceruleum for the respective shadow areas.

Raw sienna Perhaps, after white, the most frequently used 'vehicle' in the landscape palette. It

can be used with ceruleum for a mid green-grey and with french ultramarine for a darker version of the same, while with viridian it achieves a strong midsummer green. In fact, by adding Winsor lemon to the list a range of greens can be obtained to satisfy any variation the landscape may offer.

This is, indeed, all very expressive and versatile, but offers by no means the only options available, and there exist some exciting alternative solutions to all colour-mixing challenges. Many painters advocate the set-piece greens such as hooker's and chrome, achieving their own variations and harmony by mixing these with raw sienna and the various blue primary options. Experience in the field eventually becomes the basis for the final chosen palette, but whatever the final shortlist for the individual, it should still be restrained to a maximum of probably ten or twelve colours. However, there are often, tucked away in the box, some colours reserved for that special purpose – a particular light effect, perhaps, or a variation on a theme requiring some expression of added value – and these can include such colours as permanent magenta, chrome green and monastral green. I

might use these on occasion; for other painters they are stock in trade.

Cadmium red A most useful bright red, available in a light and a dark version. The light version is the true poppy red, and can be heightened with Winsor lemon for those poppies receiving light and mixed with ceruleum blue for those devoid of it. This use is demonstrated in the painting *Poppies, Old Denaby Ings* opposite.

Cadmium orange Another versatile colour for use with french ultramarine and ceruleum blue to make, for example, warm and cool brown tones. Used sparingly with white and Winsor lemon, it provides a warm, intense light tone,

SEA AND SAND, ABERDARON
Oil on canvas, 30×24in (74×60cm)
I never cease to be fascinated with the shimmer and reflective quality of a beach at low tide when viewed, as with this work, directly into the morning sun. Contrasting wet surface textures yield formidable challenges for the painter. The figures draw the eye through the waves and so on out to sea. I imagine we all have memories of carefree days such as this, if we care to reflect.

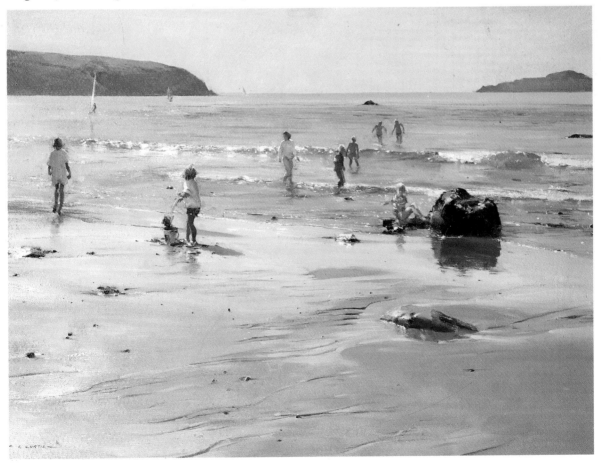

useful for the top-lightening of figures appearing against the light. You can see this effect in *Sea and Sand, Aberdaron* on page 23.

Cobalt violet A very expensive pure pigment, offering a versatility of subtle purple-greys when mixed with ceruleum or viridian. There is a less expensive version in the Alkyd range.

Viridian The only actual green in the suggested range of colours. The artist-quality version is very subtle and non-insistent; the student quality has a colour weight of greater intensity.

French ultramarine Mixed with burnt sienna, for example, this achieves as strong an intense dark as is generally required. Without the use of white it retains a certain transparency that lacks the opaque feel of some other dark mixes. The warmth or coolness of the dark can be varied by the quantity of burnt sienna used.

Ceruleum blue Another colour which is now expensive, but is perhaps the next most frequently used to raw sienna in this list. It finds itself in practically every mix, a beautiful non-insistent blue, creating much of the tonal unity which is possible with this range of colours.

In general, choose 38ml tubes for all the colours other than titanium white, for which the 115ml size is more convenient due to its liberal use in most mixes of colour.

OTHER EQUIPMENT

THINNING AGENTS

These include genuine turps and turps substitute, linseed oil and the quick-drying 'gel' medium. So often in students' work, there is evidence of too liberal a use of these thinning methods: to maintain controllability, it is advisable to *minimise* the fluidity of the mix, except in the early wash stage (ie the blocking in of the basic subject matter, where there should be no inclusion of white paint). From then on, a sparing use of turps ensures a drier approach, a longer controllable painting time, and avoidance of the 'creaminess' which can so often overtake a painting and render it unworkable in terms of being able to achieve the necessary light and dark tones with any effect. Linseed oil can compound the problem, unless used with great restraint. I

use it only in selected studio painting and never when working out of doors, where a sense of urgency is necessary to capture that fleeting light effect. The 'dry' approach seems to work better under these circumstances.

For speed in the drying process, a quick-drying gel medium mixed with the colour is a practical solution. Genuine turps has far greater quick-drying properties than turps substitute, providing one can stand its oppressive smell.

PAINT RAGS

A relatively minor, though indispensable, item in the armoury of the oil painter is the paint rag. This needs to be an absorbent cloth and preferably not of a man-made fibre. Perhaps the ideal is a good, worn-out flannelette sheet, cut into about 18in (45cm) squares. Anyone who paints on a daily basis will be aware of the vast number of rags which can be used and discarded, and the search which ensues for new supplies around friends and neighbours!

BOX AND EASEL

In order to contain all this equipment methodically in one unit, you will need to choose a box which suits your individual requirements – and your pocket. For the occasional painter, a self-contained rectangular oil painter's box with built-in palette, paints and brush compartments is ideal, and the cost reasonable. Go for one of the larger ones where the palette size will be in the order of 11×15in (27×37cm).

The ultimate in equipment containers, however, is the combination box/easel. This piece of kit offers a complete package for the outdoor painter, including a built-in easel system with three retractable legs and a fully compartmentalised box for all the year. Its most important asset is that of absolute rigidity in the field – a factor not to be underestimated, as painters who have wrestled with a canvas 'twitching' in the wind on a conventional easel will testify.

On a completely different scale, for those little gems (if you're lucky) produced at around 8×6in (20×15cm), there is the *pochade* type of box. All the necessary containment, complete with sliding palette, is neatly housed in a piece of equipment measuring no more than 9×7in (22×17cm). Designed to rest on the lap while in use, this box is a godsend for working speedily on site or from inside the car during inclement weather. Whichever form of *pochade* box is chosen, the limited space means that it should be stocked with 22ml paint tubes only.

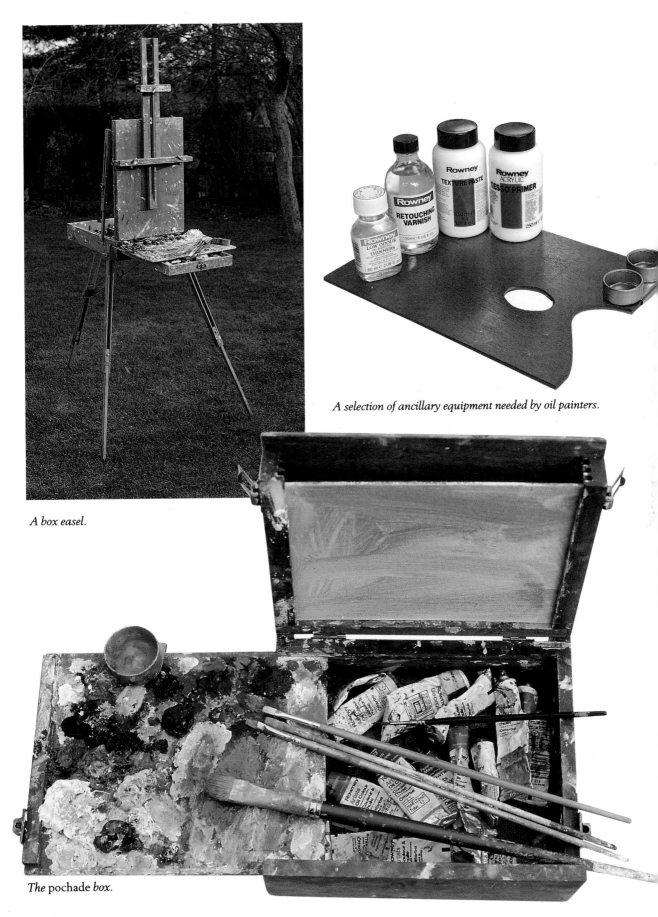

A selection of ancillary equipment needed by oil painters.

A box easel.

The pochade box.

STEP-BY-STEP DEMONSTRATION

OLD STACKYARD, CLAYTON

A traditional stone-built farm and stackyard complex was chosen for this exercise. I had to settle for a position a little further away than ideal, for the farm traffic was expected to be in and out of the yard all day. The very situation I did *not* want was to get in the way of its day-to-day proceedings, so I set up the easel on the verge on the opposite side of the road. Occasionally, to be just a touch remote from the subject is an advantage – it has the effect of 'encapsulating' the scene and prevents the painter from perhaps seeing too much detail.

Rather than take in all the elements of the scene, I chose to home in on the more central features, where some interesting shape and colour was to be found. The top edge of canvas would encompass the greater portion of the tree forms, and it was decided not to include a large area of sky. The horizon line would be set somewhat below half-way, but probably not on a true Golden Section. Quite often, once one or two parameters have been set, the remainder of the composition – if drawn correctly – should fit nicely into place.

This was a hot, sunny, though sultry sort of day, with the sun positioned at the commence-

ment of work at about the top right-hand corner of the image as related to the canvas. I assessed there would be probably two to three hours of painting time before the shadows would strike well across the surface of the yard. As they stood, they gave a reasonable impression of a 'lead-in' and formed quite interesting shapes, effectively breaking up the rather featureless, flat surface of the yard. It was clear some figurative inclusion would be needed to add a degree of activity to the foreground.

Since there were strong light areas and dark central blocks within the subject, I decided to carry out the 'rub-out' technique, and therefore chose an 18×22in (44×54cm) canvas board with its white surface untouched. This approach would be ideal for the essentially strong, simple shapes and contrasts.

The palette used for this demonstration was exactly that outlined on page 21, with few if any additions. The work is a tonal piece and relies for its success on (hopefully) subtle variations of a relatively close tonal range in the broad central area of the composition.

STAGE 1

A relatively fluid wash of french ultramarine and raw sienna was applied over the entire board area, and the immediate wetness was then re-moved with a rag to leave a fairly uniform mid tone, in readiness for the lightest areas to be rubbed out down to the canvas base. Following some sketchy constructional lines to establish, very broadly, the planning of the composition, the rub-out stage was employed as shown above right.

The essence of the image had already begun to emerge. In this case, the optimum positions of the shadows were now fixed and were adhered to throughout the production of the piece. In addition, some information, linework and colour was indicated in the structure of the tractors. Since they were well positioned in terms of composition now, and the chances were that they

would move during the painting period, any details which could be secured at this early stage were recorded.

By working the image in an overall way and attending to no specific area on the board, there is already a feeling of unity to the work as a whole, even at this early stage.

STAGE 2

Now come the first steps in establishing the strongest darks and some indicators of mid tone, employing local colour. The tree masses were blocked in with vigorous 'scrubbed' strokes, graduating towards a darker version of the tone as the shapes met up with the building forms. French ultramarine, raw sienna and a little viridian were chosen for this generally simplified

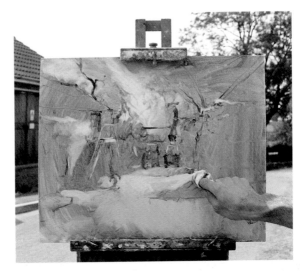

STAGE 1

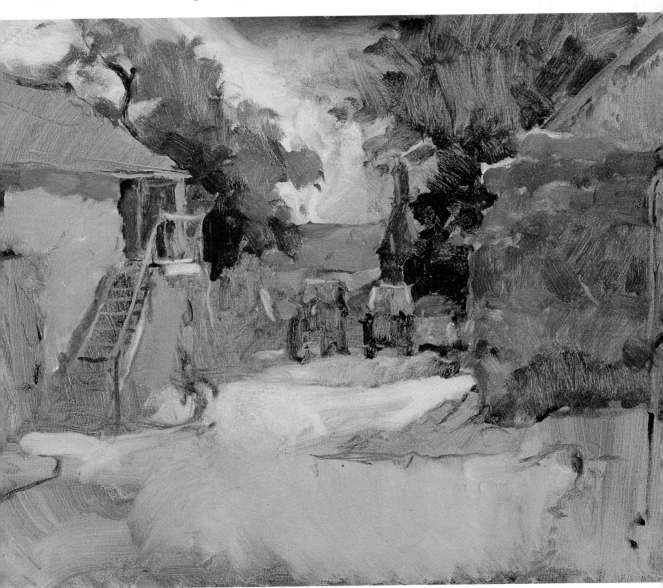

STAGE 2

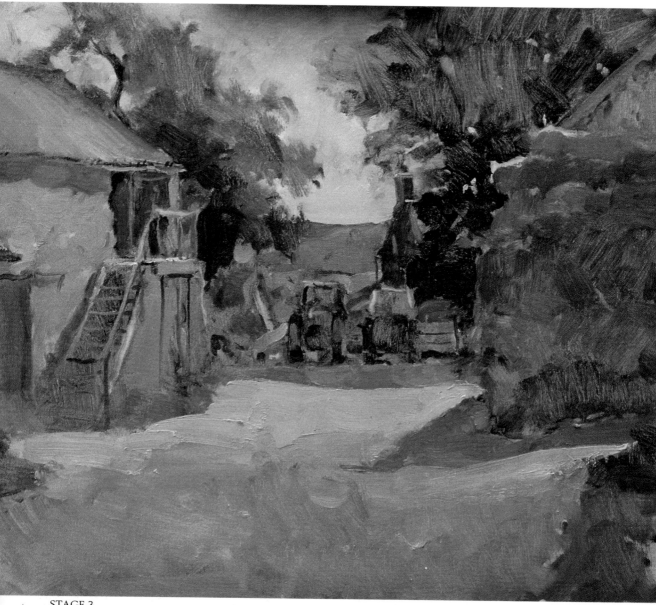

STAGE 3

area, which in effect acts as a backcloth to the middle-ground features. By forcing the dark in this way, it is possible to create a sense of space and separation from one plane to the other.

The existence of shadow-related form was now fixed on the left-hand side barn feature. A five-tone shift was needed to secure this: a dark rectangle for the open doorway punctuated by the light-toned handrail sets the two extremes, within which lie the three intermediate light and mid tones of the remainder of the structure. The image should define this clearly. Ceruleum blue, raw sienna, a little cobalt violet and white achieved the varying degrees of tone and colour balance required for this section.

On the right-hand side, apart from a rather useful glancing, top-lit edge to the stacked hay bales, the remainder of this area is observed largely in shadow. A graduation of cool to warm tonal mixes was formulated in slabs of colour applied to this relatively simple foil to the rest of the composition. By keeping the right-hand side as a whole mainly in shadow, the emphasis of light has been thrown nicely onto the elements on the left.

As the farm machinery was still in position, I made capital out of this by securing as much loosely stated detail in the shapes as was possible at this stage. No area received more time or attention than any other, in order to maintain the unity originally achieved in Stage 1.

To complete this phase, a simple mid-tone

block for the central, more distant roof was applied to tie in all the central elements of the subject and set a tonal scheme. The next step was to assess the sky area as the light source and the foreground, sunlit surface – as the broadest single area – as the receiver, one half-tone down and a little warmer than the sky-colour value.

STAGE 3

With the central band of the composition set in place, the sky area was produced with titanium white, ceruleum blue and raw sienna in a way which filled in the original rubbed-out area and matched into the form produced in Stage 2. The sky tone accentuates the strong resolved shapes and utilises a little of the lost-and-found edging for the less hard-edged passages of the peripheral shape.

With a mix as suggested above, tonally lower than that for the sky, the foreground section was laid in simply, reserving the lightest area for the further middle distance and increasing the weight of tone as the area reaches near foreground. This serves to 'cushion' or contain the composition and so draw the eye into the central, focal area.

Since the cast shadows are a cooler, 'bluer' version of the actual lit surface, the unity of the whole surface was further assisted by introducing the cooler element of tone into the parent mix just employed. Using this mix, and observing carefully the slight variations of tonal weight, the shadows were firmly stated.

An hour or so had now elapsed from those initial skeletal lines to the completion of this stage. I needed to have all form and an overall feel for the light of the day well established within this time scale in order to stand any chance of remaining in full control of the task. At about this time the light was beginning to alter quite markedly from that which had given greatest appeal at the outset, so the fixing of that impression, firmly in place within an hour, then allowed the remainder of the time on site for the consideration of elements which were not so directly affected by the changing light.

STAGE 4

Sundry forms and shapes, all gradually brought out with firmer resolution from the original Stage 2 working, were now intended to draw out

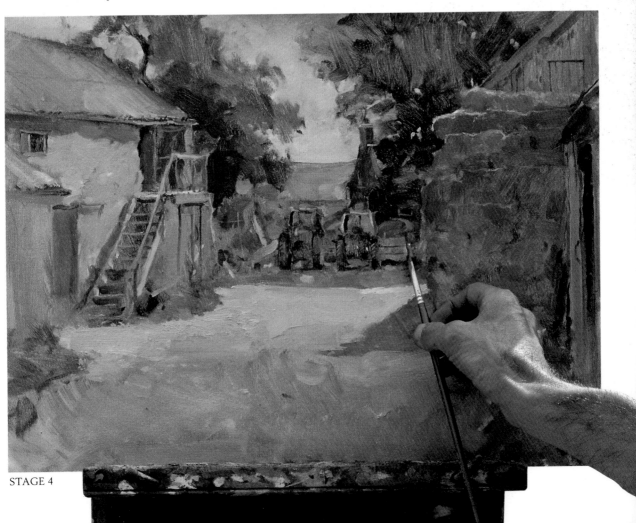

STAGE 4

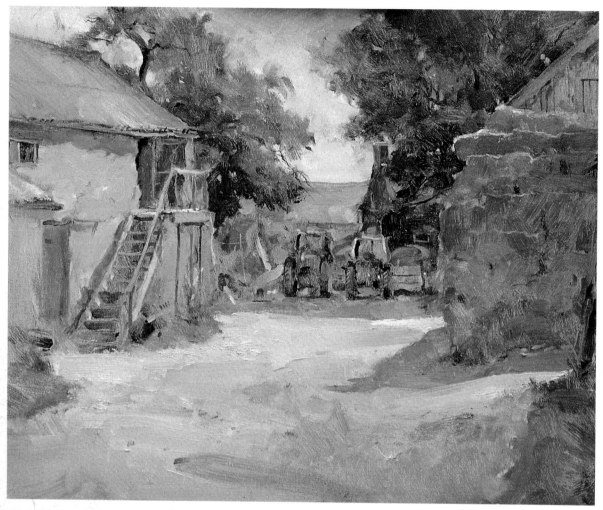

STAGE 5

the character of the place. Although slowly becoming more easily identifiable, they were not worked to too definite a degree of finish.

As I had feared, with the farm activity now in full swing I began to lose the tractors one by one from their ideal original placings, so my early observations had to suffice.

Often at this stage a few well-resolved key passages increase the expectation of an acceptable final result. The feel of the stepladder with its subtle offering of counterpoint served now to lend a three-dimensional quality, while the beginnings of further attention to the right-hand side recorded details within the area in shadow and began to pull the work into shape. I chose to leave unresolved some peripheral areas of limited interest in order to concentrate the eye on these more considered facets.

Essentially this stage is a reassessment, emphasising doorways, windows, eaves and gutter lines – in fact, all aspects of the building's character.

STAGE 5

Some two hours into the exercise, I now turned my attention to building more structure into the tree forms – just sufficient so that the area did not compete overly with the detail observed in the barn complex. These understated, restful areas are always worth looking out for, as they add interesting variation to the overall textural quality of the piece. Similarly, I carried out some further modelling of the foreground, again with economy of application.

Standing back from the work at this time, it was possible to view it objectively and decide how successfuly – or otherwise – the unifying process had been. Did each element work in isolation, and also as part of the whole image? Did these elements convince in their relative portion of foreground, middle or far distance? Did the painting, overall, look empty?

I felt the first two factors were probably reasonably on target, but there was an empty feel

to the foreground – a fact I had wondered about at the start. Maybe a little less foreground might have been helpful, but then there would not have been a lead-in quality and the restful area was, on balance, a desirable feature. The best plan was to cut into the horizontal at the middle distance with a figure suitably placed off-centre, just sufficient to add life and give an indication of scale to the work.

STAGE 6

Several farm personnel appeared from time to time, crossing the yard, so I made use of one of these moving towards the barn steps. With due attention to its scale relative to other features of the scene, the figure was placed as shown, to give

a feeling of purposeful movement. Clothed in a light shirt and dark trousers, he created an effect of counterchange, assisting the feeling of space generated between himself and the middle to far distance.

Finally, I carried out some tidying up, essentially to the tree forms, where I accentuated some of the tracery of branches to give the trees a fuller character, and I also added a few dark notes, such as the window aperture on the left-hand side. These few touches brought the work to a degree of crispness quite sufficient for the method employed. Any over-indulgence in this tidying-up procedure would lose the immediacy of interpretation and inevitably lend a tight, laboured feel to the finished result.

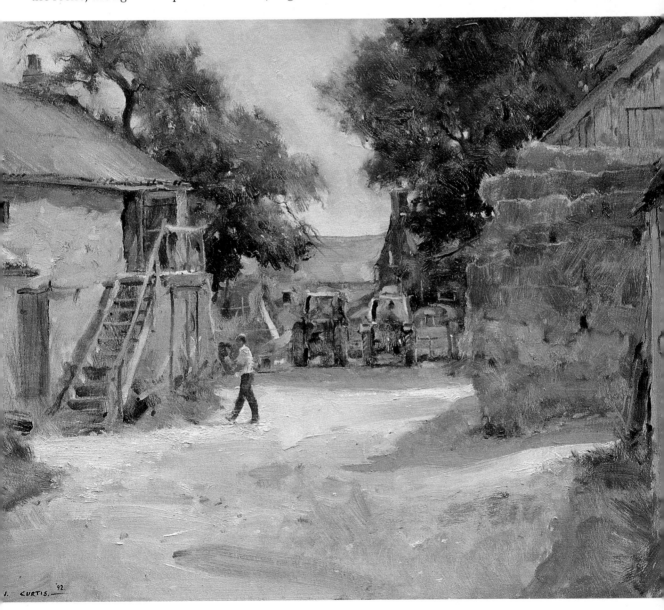

STAGE 6

CHAPTER TWO
MAKING A START

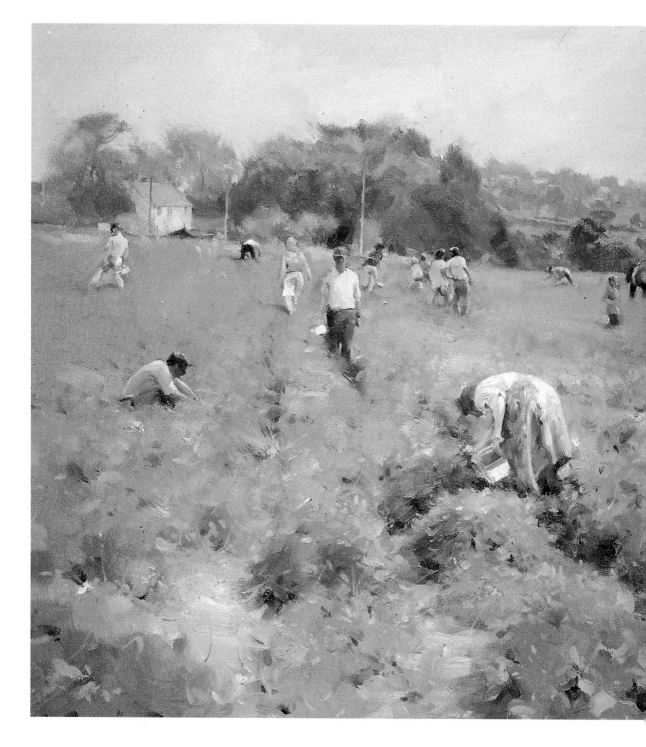

Delving deep recently into the reams of old drawings, watercolours and oil sketches of years gone by which languish in the store cupboard of my studio, I noticed that whilst the various experimental techniques employed seemed rather hit and miss in terms of success level, the underlying effectiveness of composition appeared to be fairly consistent. The early years of consistent drawing practice had evidently sown the seeds of what eventually became an almost subconscious appreciation of effective composition.

I recall a sound maxim we employed at the time – 'Composition, tone, colour' – essential elements, considered in that order of priority. A well-composed subject layout can often stand up well enough to scrutiny, even though the subsequent application of paint may display limited technical ability. Without the core element of good composition, however, the result would not hang together at all convincingly, even with a moderate degree of expertise in the subsequent painting.

There are a number of points to be considered during the preparatory work which leads up to a decided composition of the subject you see in front of you.

FRAMING THE VIEW

Bearing in mind that the painter selects only a tiny portion of the whole 360° panorama, it is a good idea to employ a subject 'containment' method. This can be nothing more than forming a 'frame' with the thumb and first finger of each hand (see below). A cardboard rectangle with a suitable proportional aperture can be equally effective.

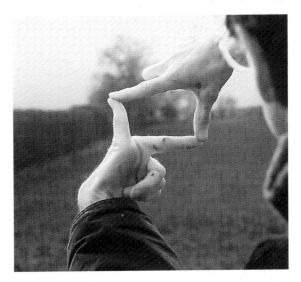

'Frame' a subject with your index fingers and thumbs.

PICK YOUR OWN
Oil on canvas, 30×24in (74×60cm)

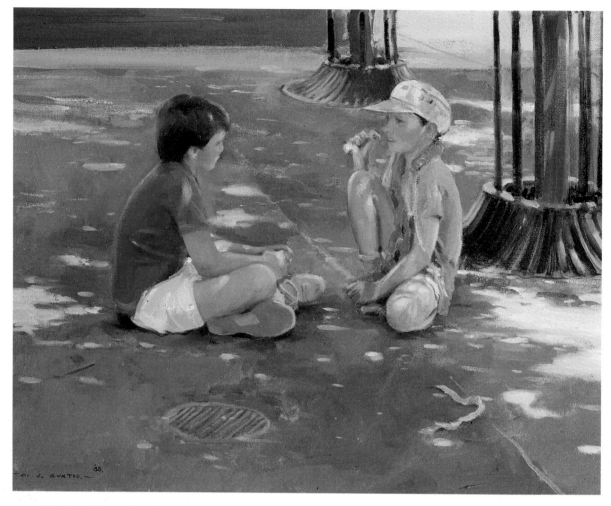

THE GOLDEN SECTION

A certain awkwardness of composition occurs when important features of the subject matter appear too close to the vertical and horizontal centre lines within the canvas area. Here, the 'Golden Section' rule applies. Some possibilities are illustrated here and can also be identified in many of the other paintings reproduced through the book. Not wishing to be tied too closely to definite rules, however, I might on occasion deviate from the principle to the extent that the safe option is punctuated by perhaps a more daring and risky composition. On the other hand, during the painter's formative years it is probably wise to learn and put into practice those safe essentials of the craft and gain a thorough understanding of all the various ground rules, before embarking on that work which may establish a particular personal identity and one day bring the painter to the attention of a wider audience.

Dimensionally, the Golden Section is re-

CONVERSATION PIECE, TORONTO
Oil on canvas, 16×20in (39×49cm)
Here the two figures satisfy their positioning on the Golden Section, each a third proportion in from the side of the canvas. The interest here was in the play of dappled light on the subject as a whole, and in the opportunity for subtle counterchange effects throughout all the shapes and surfaces.

garded as a split of one-third proportion in from the left- or right-hand side and equally a one-third proportion in from the upper or lower horizontal edges. In the vertical plane, features which might be given Golden-Section positioning include such elements as church spires, major tree features and strategically placed foreground figures. Typically, the choice of position for the horizon within the composition is the determinant of the horizontal Golden Section features.

Low-horizon compositions offer an opportunity to emphasise a dramatic sky effect, often with the play of light cutting across a distant

landscape pattern of opposing sunlit and shadow areas. For increased drama, the horizontal can be pitched lower than the suggested one-third proportion, when the landscape becomes merely an indication of a base between sky and land.

Edward Seago, perhaps one of the finest exponents of the *plein air* movement of his time, specialised in this type of subject. Many have attempted to emulate his style but he remains, in my view, the true and original master of that free and vibrant landscape treatment. Today, Trevor Chamberlain, an adherent of the finest principles of pure outdoor painting and, in my opinion, an equal of Seago in capturing the fleeting light effect, often employs the low horizon.

The use of the upper Golden Section – one-third down from the upper horizontal edge – means that greater attention and importance will be given to the land mass. Herein lies one of the

REBECCA, LOW TIDE, SANDSEND
Oil on canvas, 30×24in (74×60cm)
Adhering to the principle of a sound composition being based on strategic elements placed on or near the Golden Section, in this painting the horizon is on the upper horizontal Golden Section with the little girl, Rebecca, the main player in the foreground, positioned one-third in from the right-hand side of the canvas. One or two carefully considered points like these in a composition will assist in producing a well-composed, balanced image.

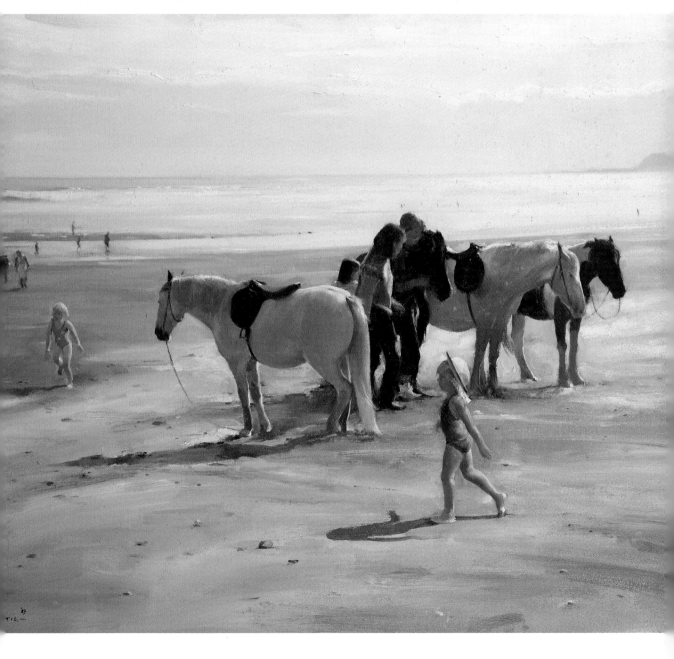

A SHARP FROST, TICKHILL
Oil on board, 14×10in (35×25cm)

great fears of the student painter – the inevitable inclusion of a considerable area of foreground content much of which, on the face of it, may not offer a great deal in the way of interest. Just as with the special skill of the sky painter, here is a particular challenge to be overcome.

It is through a feeling of design and 'lead-in' that one can use the space to great advantage; a typical example would be the leading of the eye along a twisting pathway up to some dramatic point of interest. Furthermore, the ability to re-solve foreground areas in close-toned blocks or masses, and to go for sweeping shadow areas and the inclusion of figurative interest, will all enable the painter to increase the features of interest.

As I am, perhaps, more fascinated by what the light source (the sky) does to objects and areas than by the source itself, I tend to lean to-wards subjects employing a greater land mass, as many of the paintings in this book may suggest. This has meant devoting considerable time to developing techniques to deal effectively with this challenge. Typically, as with the beach sub-jects shown here, there becomes available a space in which to compose those fascinating groups of 'back-lit' figures assuming such a diversity of poses – a source of endless material.

The surface texture of wet sand also requires

a large area for it to be totally expressed, and the high horizon allows for this. Any feeling of real space usually suggests the need for this as well. In addition, the special fascination of a subject viewed from a high aspect will invariably require a particularly high horizon, and with careful perspective a real feeling of height can some-times be achieved.

LIGHT

From all this, it can be seen that the choice of high or low horizon, the placing of verticals and of the main objects of interest, are the basic parameters of subject choice. Whatever the appeal of the placement of the elements within the landscape, however, that appeal is always affected by the light effect available at the time of viewing. Often the same subject can become attractive in different ways simply through an alteration in the light source. Since on-site paint-ing time should be limited to two or three hours per subject, due attention should be paid to the change the light may make to the subject.

Light directed from the left to the right of the canvas yields interesting shadow forms, which in themselves can help resolve and organise large, awkward foreground sections. Painting early and late in the day increases shadow length and has been held as a sound basis on which to work by painters for many generations. Painting with the light directly behind the canvas can offer scope for a good degree of direct colour, but difficulties often occur with the lack of form and contrast of the shapes within the composition.

The ultimate – and incidentally the simplest – dramatic effect is that of painting directly into the light, as mentioned earlier. All shapes become simply resolved, extraneous detail is fixed into single blocks, strong contrasts occur everywhere and shimmering, glancing light becomes the norm and the most played-upon feature in the composition. Any figurative interest will enjoy a lit edge, often appearing all round the perimeter of the shape – all these ingredients are an absolute joy to work with and, with careful control, can produce the most

memorable results. To capitalise on the reality of the shimmer of a light passage immediately against its darker adjoining area, the meeting of the edges can be softened slightly with what is basically an orange/red mix with white. This in essence is what the eye sees, and reproducing it does seem to enhance the intensity of that visual experience on canvas. *A Secluded Bay, Gairloch* illustrates this, I think to good effect.

We must not disregard or minimise the value of flat light, however. With careful observation and the right choice of subject, this condition enables the painter to produce toned effects of

A BEACH AT ARISAIG
Oil on canvas, 30×24in (74×60cm)
An especially high viewpoint was used for this summer-evening beachscape on the far west coast of Scotland. Essentially, the canvas is split diagonally, suggesting two totally diverse surface textures of sea and sand, and punctuated in a simple way with just a few figures producing the long shadows of this late daylight hour. The positioning of the shadows leads the eye towards the central, sunlit area on the surface of the wave forms.

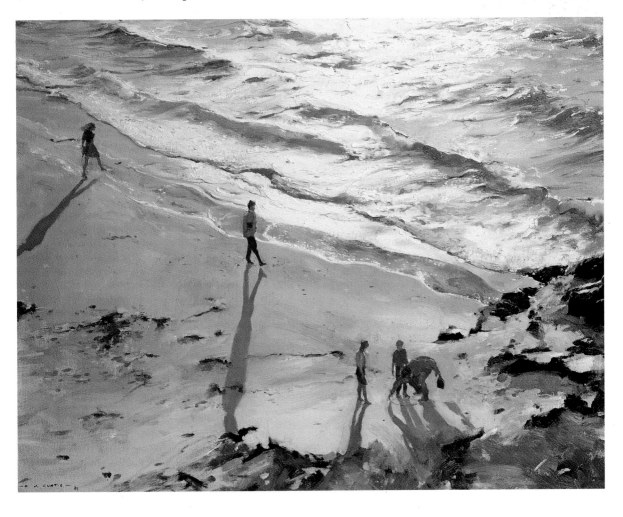

minimal contrasts. Look at some of the work of, say, two Newlyn School artists, Stanhope Forbes and Walter Langley. Here, the range of the palette is minimised, perhaps to no more than five or six colours for each work. I have found a useful range for such applications to be french ultramarine, ceruleum blue, raw sienna, light red and viridian. With the addition of a primary red and yellow for particular subject choices, the range is suitable for both oil and watercolour work.

The rigorous discipline of painting outdoors hones the technique into a much more formidable painting quality, giving each stroke a sense of urgency, with the greater likelihood of a vibrant result. Sometimes, however, the enthusiasm backfires and it is all too easy to be carried away with a fleeting light effect that suddenly disappears. You then soldier on, trying to remember the subtle nuances, but rarely does the memory honour the actuality of the event.

OTHER CONSIDERATIONS

In the initial enthusiasm of finding a subject that appeals, and being satisfied with the light source, it is easy not to use the placing of the elements on offer to best advantage. The basics of the placings may be satisfactory, but a really enduring design requires all the sub-elements to 'knit' together, making the total subject unique and memorable. Do not hesitate to move things around a bit – or condense, stretch or leave elements out – in fact, use any modifications which may work to enhance the composition. This 'artist's licence' is a unique facility, and experience is the best judge of its use.

I suppose there is always a fear of running out of subject matter in the immediate vicinity of

EVENING LIGHT, MYKONOS
Oil on canvas, 30×24in (74×60cm)
This rocky foreshore study on the Greek Island of Mykonos is based on a similar theme to A Beach at Arisaig. Again a diagonal-based composition, it wrestles with the rigours of trying to capitalise on the shimmer effect of a late-evening sun on wave forms, contrasting with the warm glow of the sun on this dramatic rocky coastline. Figurative interest is provided by the fishing party at sea level, the rock structure leading from this to a further single figure at its highest point. Areas of relative simplicity, like the treatment of the sea, are a welcome foil to the much more complex treatment of the foreground detail.

home and studio – in other words, 'painting the place out'. This fear inevitably surfaces from time to time, but one always seems to find something new eventually. The shifting seasons and changing light of the day can create tremendous potential around a favourite old subject. The eye seems to take in different qualities on subsequent visits, and even a small shift in vantage point can yield a totally different feel. Shifting the horizon line from high to low and vice versa, also alters the feel of the subject completely.

DRAWING

To become totally absorbed in capturing the complexities of a scene generates a particular sense of satisfaction. How often have I heard the comment, 'I can't tackle that – there's too much drawing in it'. This is some painters' greatest reservation. Since pure drawing at an early stage of development is really the absolute prerequisite for all future success, it makes sound sense to practise this rigorously at every available moment, until after a time the language of drawing feels as familiar as being able to write. Armed with this confidence, the painter will then feel able to search out the more complex and enduring subject matter – that which may well offer some of the advanced elements of real design.

With this challenge ahead, you will need to plan your progress carefully. Should the light be flat for any length of time, you will be able to enjoy an extended painting period on site. Though not immediately as attractive as the sunlit scene, great subtleties can be gleaned from the close-toned image before you. The greater complexity of drawing content can in such instances transcend the possible lack of colour and shadow on offer.

TIMESCALE

Using a canvas size of up to, say, 20×24in (49×60cm) on location, it is preferable, if possible, to return to the subject site on other

A SECLUDED BAY, GAIRLOCH
Oil on canvas, 30×24in (74×60cm)
This is a studio painting based upon a small oil study produced on the spot. The special challenge was to go for a 'softening up' of certain edges and forms as they met the glare of direct sunlight. By this fractionalisation of the shapes, and the use of warm, glowing orange and yellow integrated into the mixes of darker colour, some degree of the feel of this light effect has, I hope, been achieved.

occasions should conditions allow. If sunlight is present, it may be advisable to decide on a period of two to three hours for each visit and stick to this timescale until progress is complete. Work completed wholly on site, even after several visits, seems to engender more life than that completed with the aid of photography, where an unintentional tendency to tighten up the image can creep in. If, however, the painter has the experience and discipline of using photography merely as a minimum reference and can maintain those painterly strokes as on site, then the 'insurance policy' of the photograph can be of benefit.

Some effects, especially those worked on site

and directly into the light, will require discipline and the utmost speed of execution. It may be best to select a smaller board in order to remain in control of the image, though added dynamism can be effected if one has the confidence to paint with vigour using large brushes on a larger surface area.

As mentioned earlier, I regard Trevor Chamberlain as a master of the fleeting effect. Never resorting to the assistance of the camera, here is a painter of the utmost integrity who has the ability to register in his mind that frozen moment of effect and then faithfully convey it on canvas. I have witnessed that enviable facility to retain in

the shining, vertically mounted exhaust stack so typical of the machine, and with the light bouncing off various shining parts. I thought what a wonderful inclusion it would make to the subject, but there it was – seen and gone! When next I glanced at Trevor's work some minutes later, there it was – fully in place on the road in sufficient detail as to be wholly effective on the board. This is a fine example of the particular skill of a photographic mind, a skill honed from many years of acute observation, working on site.

SELECTING A SUBJECT

The initial appeal of a subject – that 'gut' feeling about the content – is a factor which can work both for and against the finished result. What might have immediate impact at the point of painting may not endure once the canvas is removed from the site. The reverse is also possible, of course: that insignificant little piece, the one you had little faith in, can prove to be more effective away from the subject.

In commercial terms, there are sometimes paintings you are quite excited about, but which never find a buyer for some odd reason. I think it boils down to the elements within the image and whether or not they exude a certain presence. The great challenge lies in making the simplest statement exciting by any means to hand, be it by searching out colour harmony, through the particularly clever placing of the shapes, or by creating a genuine feel of space and form. When observing colleagues at work, I have often witnessed a successful result emerging from a really vague subject in front of them – and certainly one which I wouldn't have chosen! The lesson is that what appeals to one painter doesn't necessarily work for another. Certainly, I prefer to attempt subjects with lots of activity and content – probably because I enjoy the drawing side so much.

Choosing a subject is a very personal affair, but it always pays to seek out the right viewpoint at the right time of day. It can be so easy to go for the obvious, especially with commercial considerations in mind, having probably missed something close at hand which might offer that little bit extra in terms of composition or content. The material with less immediate appeal can sometimes prove more enduring in the long run, and offer a unique quality lacking in the run-of-the-mill subject. It may, for instance, simply be a

OLD STACKYARD, MISSON
Oil on canvas, 30×49in (74×125cm)

mind the fleeting moment, both in light effect and the movement of figurative objects of interest as they pass across the subject, in Trevor's work on many occasions. One such instance took place whilst we were on a painting trip in Connecticut, USA. Having selected a rather attractive street scene featuring the appealing colonial clapboard buildings typical of the area, we began to get involved in all the intricacies of the subject. Up the wide roadway trundled a gleaming American-style truck, complete with

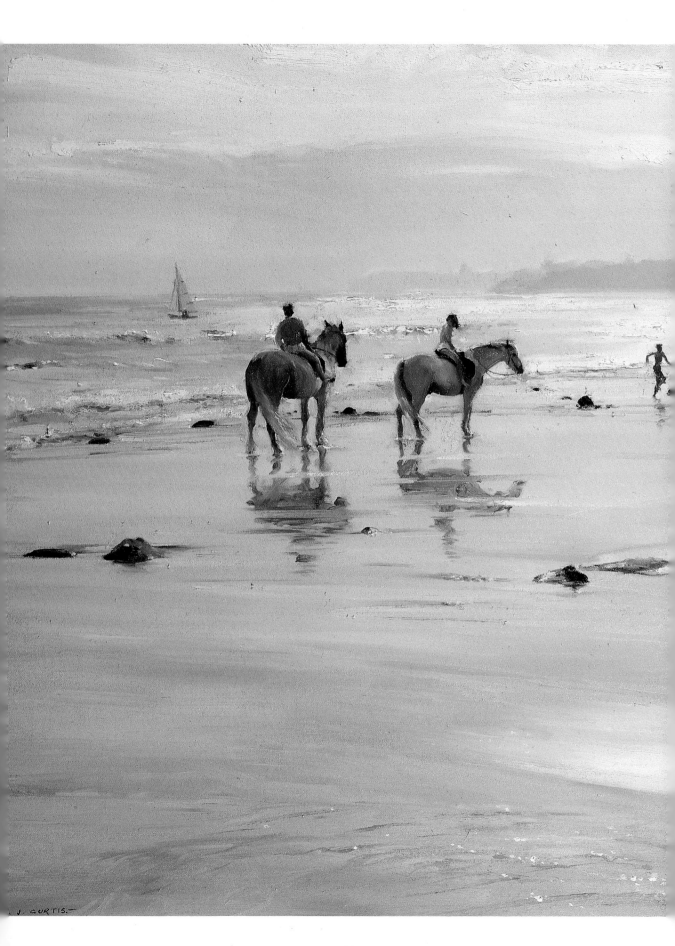

conventional composition viewed from an odd angle, perhaps a low vantage point which accentuates the perspective of the elements, or a raised viewpoint which gains the high horizon. Some memorable variations can also be realised through viewing from an upstairs window, and this interior/exterior consideration adds greatly to the potential for material. Whilst not strictly satisfying the criteria of landscape, the interior/exterior viewpoint combines the possibilities of the external elements with some of the mystery of a dark interior, the subject elements not fully resolved in form and thereby demanding more enquiry and feedback from the viewer.

MAKING A START

Each demonstration in this book is followed through in detailed stages, but it is worth outlining some broad ideas and parameters covering the choice of painting surface and the sequence of operations, from the initial drawing to the placing of all light, mid and dark tonal areas.

CHOICE OF SURFACE

Once faced with the subject, the choice of board or canvas surface may be crucial to the eventual success – or otherwise – of the result. I definitely believe that the subject dictates the choice, as well as whether to go for a toned surface or one which is left white, where the rub-out technique can be employed. This is preferable where some element is in great contrast to others.

I recall recently selecting a subject on my favourite stretch of beach which, on an afternoon of strong sunlight, offered one element – a white beach hut standing bleached against a deep blue sky. Here was the ideal case for the rub-out technique. I first washed in the broad areas of sand, sea and sky right across the board with mixes of french ultramarine, raw sienna and cobalt violet, all with adequate amounts of turps (and no white body colour), somewhat like the overall wash one would employ in the initial stages of a loose watercolour exercise. With a clean rag, I then rubbed out the intense white shape of the hut, back to the white board surface – with immediate effect. The essence of the subject placing, tone, and some colour was fixed in a very short space of time.

Of course, a similar effect can be achieved

A MORNING RIDE, SANDSEND
Oil on canvas, 30×24in (74×60cm)

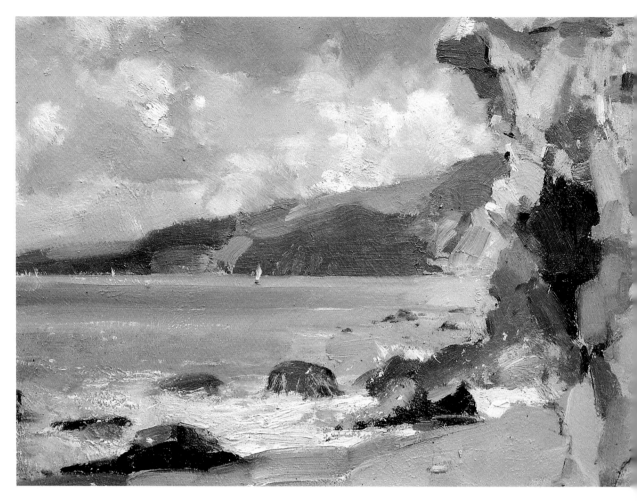

Carefully considered interlocking blocks or areas of colour serve to create a feeling of form and texture as diverse as the craggy rock structure on the right and the softer edged treatment of the sky.

with the use of a toned board by placing the beach-hut shape over the toned surface using a basically white body colour. The first option offers a more fluid approach, the feel of which would, of necessity, carry through throughout the production of the piece, where the tonal blocks might flow a little more easily than with the drier approach of the toned surface. On the other hand, more control of proceedings might be possible with the drier, more textured surface.

PRELIMINARY DRAWING
In each of these cases some preliminary drawings of the essentials would now need to be undertaken, where the discipline of stating only the basics would be a positive advantage. Some painters like to place these markings with a pencil or charcoal – I prefer to draw in directly with the brush, and so catch the feel and movement straight away with the medium I intend to use throughout. Those lines need to be sketchy and of a reasonably strong mid tone, so as not to insist and be too evident later in the painting. Using a No 1 short flat bristle with a mix of burnt sienna

and french ultramarine, this stage can be achieved effectively. With either approach, the stage of extreme light, together with the drawn image is now stated, and all subsequent stages are applicable to both.

ESTABLISHING TONES
Having established the lightest lights, it is a good idea to plot in the darkest darks. Once placed, they become a useful reference for any tonal areas which fall within the two extremes. Some structured control has then been achieved, to be followed by the matching up of all intermediate tonal blocks, eventually filling the surface area.

A whole range of mid tones exists in any landscape. Begin with areas which are broadly stated relative to the previously placed darks, and work should be directed towards covering all areas of the surface in order to maintain a sense

Urgently applied scrubbed strokes, useful for the massing-in of large areas at the early stage of the painting's progress.

Uninspired linear strokes, without dynamism. These are applied as one would gloss paint to a door.

of unity. In addressing this task, due consideration must be given not only to the degree of tonal weight but also to providing some semblance of the local colour which is present, thus establishing the particular character of the place. In order to maintain control of proceedings, use the white body colour sparingly in the mixes of tone, and avoid any possible overuse of turps or other thinning media.

There is often a temptation to concentrate too much on one section or area of the subject which may hold special interest. The problem here is that if more detail or consideration is given to that area, the finished painting will have the disjointed feel of differing degrees of working and finish. In fact, you should avoid any tendency towards finite detail. It is worth keeping in mind – and applying – the maxim 'Big, broad areas' throughout the working.

Applying the paint in solid interlocking blocks (page 46) or over larger areas in a 'scrubbed' manner (above left) is infinitely preferable to the commonly seen approach whereby the tone is applied in a single direction, just as one

would paint a door with gloss paint! This flat method (above right) seldom achieves any life or dynamism in the end result. Far more enduring is the vibrant canvas where the strokes have been applied with a certain roughness and sense of urgency, giving the impression that the painter was in a heightened state of anticipation and expectation as he or she worked positively towards the end result.

THE LATER STAGES

So far the surface has been chosen, the initial drawing-in process has been completed and the massed areas of mid tones have been applied. The next step is generally to plan any high-key tonal areas and, indeed, any highlights, which in themselves add that extra 'sparkle' to the painting, especially when the choice has been made to paint directly into the sun. All subsequent stages are a more considered, but hopefully not overworked, development of the early laying-in process.

STEP-BY-STEP DEMONSTRATION
LAKESIDE BOATHOUSE

A secluded lakeside boathouse forms the basis upon which this composition was worked out. Searching for a subject along a pathway encircling the lake, I was nearly taken in by the obvious expansive view across the lake, but I felt the finer qualities of the area lay in its more intimate aspect and especially here, where definitive form remains rather hidden, although its purpose is readily identifiable. Balanced by simple tree forms to the right and suggesting simple patchworks of receded greens, here was a subject potentially of great charm. I was eager to start, being quietly confident that I might be 'in tune' with the task ahead.

The day was one of predominantly flat light, but with the occasional period of milky sunlight. It was quite dry and very warm, reminding me of a line from Vaughan Williams' *An Oxford Elegy*: 'All the live murmur of a summer's day'. The lack of any wind ensured there would be little to disturb the water surface, so all the ingredients were well in place for the initial stage.

STAGE 1
A 16×12in (39×30cm) Gesso-primed board, pre-toned with a french ultramarine and raw sienna wash applied the day before, gave a surface ideally suited to the choice of subject. As it was not entirely dry, there was the possibility of a limited use of the rub-out technique.

Little adjustments to the reality of the scene were needed in order to enhance and draw out more of the potential of the subject. Plotting in a few basic rub-out marks with a turps-soaked rag, it was possible to set the parameters of light tone in position and achieve the most balanced composition. These areas were the lighter structure of the shed, the two adjacent tree forms and the suggestion of reflection in the water surface. Immediately following this, the darkest darks were placed, in this case surrounding, more or less, the lightest passages. The tonal scale was thus set in place.

Around this basis various mid to dark blocks were observed and then applied in a loose manner. From this stage on gradual use was made of white body colour, no inclusion of white having been allowed in the darkest passages. Next, the lighter areas of foliage were considered relative to the mid tones, attempting to ensure that all mixes were in harmony with their immediate neighbours. This meant the use of a somewhat limited palette consisting of french ultramarine, ceruleum blue, raw sienna, burnt sienna, viridian and cadmium red, the only later addition being lemon yellow for some foreground highlights. After about half an hour, all the Stage 1 elements were complete.

STAGE 2
I now concentrated solely on the foreground masses. My aim at this stage was to generate the lightly mirrored surface texture in simplified form, which would then act as a base to cushion

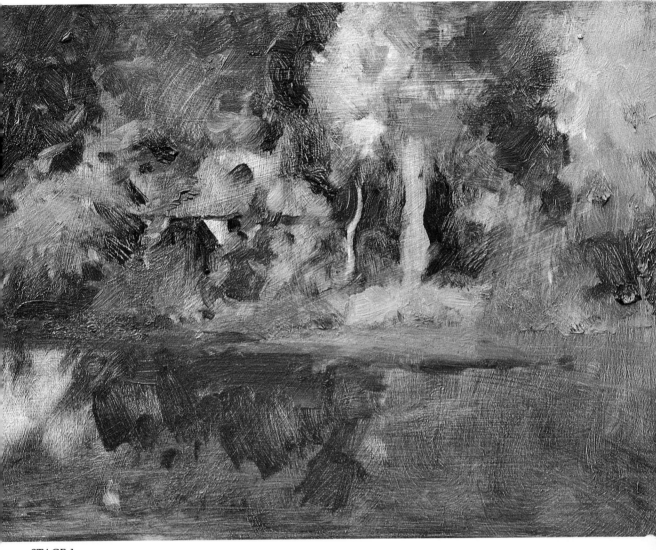

STAGE 1

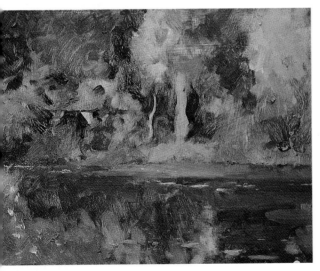

STAGE 2

the upper part of the subject area. Being largely lower mid tone, it would throw emphasis onto the lighter areas of this upper band.

On the lower, left-hand side foreground, I paid some attention to the workings of the vegetation of the foreshore, the purpose of this area being to prevent the eye from slipping away off the left-hand side of the board. Without this, the eye would tend to shift from left to right across the board and would be unlikely to settle in the focal area of the boathouse. The inclusion of the foreground detail arrests this phenomenon and has the effect of pointing the eye back towards the central area. Reflections do not necessarily mirror the objects above exactly, even in calm water. Firstly, heavily vegetated or weed-strewn conditions can break up the reflections almost completely. The weed in this calm, backwater stretch of the lake was obvious, punctuating the

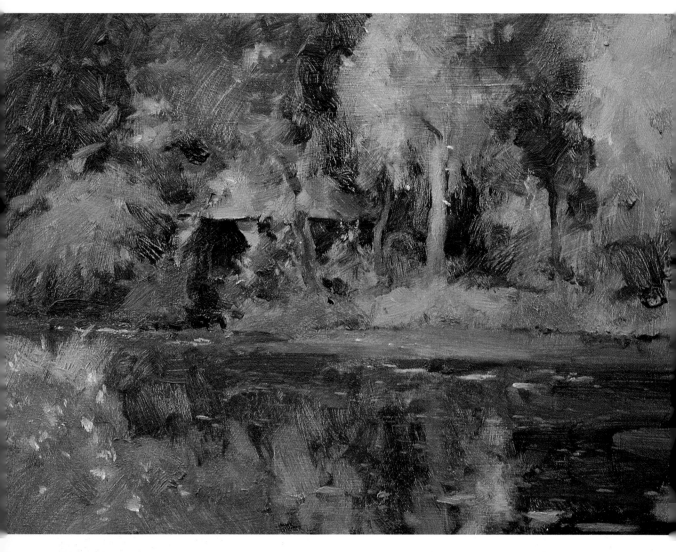

STAGE 3

surface of the water on a grand scale and largely destroying any crispness of reflected form. Secondly, it is important to note that the further back from the water's edge the object is positioned, the less is reflected of the lower portion of the shape. This occurred to some extent here. Finally, I took careful note of the general slight reduction in tonal value of the water-surface area relative to the upper land mass.

To counteract the overall close-tonedness of the piece, I added a little indication of local colour in the left-hand foreground as well as some horizontal strokes to suggest the vegetation floating on the water surface. Picking up a useful toplight, these were to be an asset at a later stage for giving a feel of perspective across the water, thus allowing the eye to travel effectively into the central focal area.

The complete surface of the board had now received some attention, and the next step was to review the subject in its entirety.

STAGE 3

At this point a degree of weak sunlight pervaded the landscape, its fortuitous timing enabling some of the resulting lit accents to be stated quickly in the painting. The most obvious of these were the two opposing triangular fillets on the boathouse frontage. The fairly intense, cool viridian green worked well, with its toned-down, shaded portion below the roof overhang. Along with a pinky light on the front face of the roof, these details made it possible to begin to put some character into this interesting, rather individual old structure. The deep-set interior dark was placed so as to state the tonal range fully, this small area of the work encompassing the complete range of tonal values perhaps more

than any other part of the subject, and thereby justifying its role as the main focal point. I employed my trusty mix of french ultramarine and burnt sienna for the intense dark of the shed interior.

The remainder of this stage was devoted to a careful assessment of the quite different colour and tone values of the nearby tree forms. With a subject of this type, lacking much in the way of definite shape and form, it is vital to be in a position to state at least some firm vertical and horizontal markers. The lake shoreline and the nicely off-centre trees fulfil these roles.

With red (warm) and green (cool) acting as complementary colours, we have here a gentle and variable, but non-insistent, version of this principle. The repeated motif of the complementary is seen in a general sense throughout the canvas, as well as in the more individual statements. The linking pink and green factors of the boathouse were now echoed in the two major tree forms – one pink, one green. The left-of-centre one also served to cut into the form of the shed and so break up the minor horizontal of the roofline. A nice chance of counterpoint was subtly suggested here with further counterchanges as the eye travelled across to the most

prominent tree on the right-hand side Golden Section, and its dark neighbour further right still.

The more I progressed with this subject, the more I was convinced that its potential quality was above the norm. Regardless of its simplicity, it seemed to have all the most favourable ingredients of colour and tonal harmony, composition and counterchange well in place. What was needed now was to remain in control and capitalise on the potential without overstatement.

Under normal circumstances, if you are fired by the subject, away you go – oblivious to time and surroundings apart from the immediate subject; not so with the step-by-step demonstration! You just get into the swing of things and the cameramen steps in … 'Another shot now, don't you think?' Usually, there are between five and six interruptions of this sort. With good humour, and a photographer sympathetic to the psyche of the painter, all is achieved in harmony. Any demonstration, live or photographed, remains a very personal test piece for the individual.

STAGE 4
At about this time I considered introducing a figure, perhaps in a boat. After some

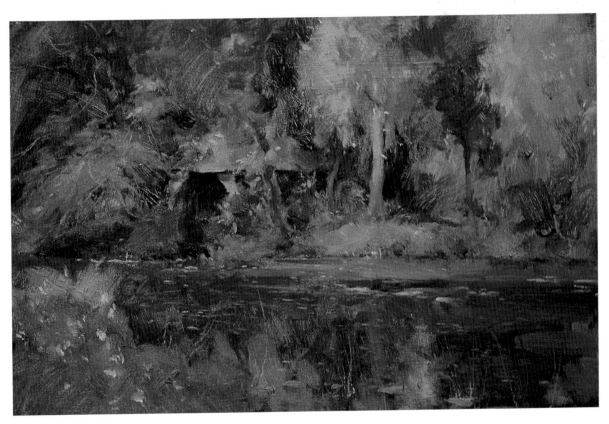

STAGE 4

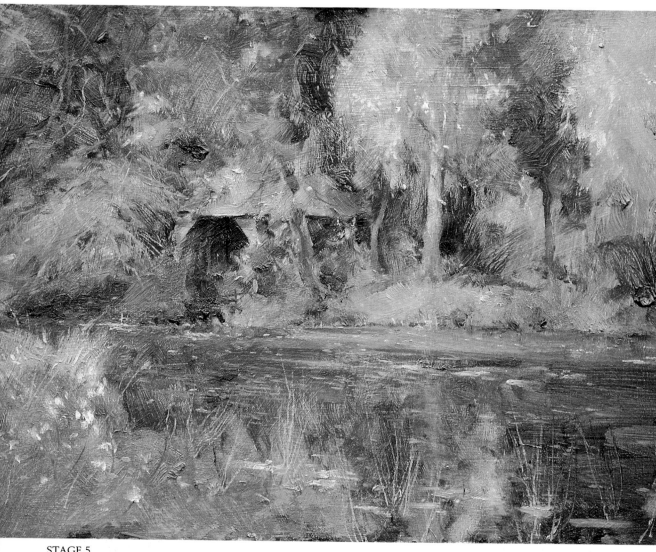

STAGE 5

deliberation, however, I opted against the notion, deciding that in this case it was probably unnecessary and even a bit hackneyed. Often figures are a desirable element, but some subjects hold together quite nicely in their absence and offer a complete enough image of simplicity and serenity.

I now concentrated on a few of the textural additions to the initial blocked-in masses of tree and ground-level foliage. It was a period of selectivity, and of assessment of the lost and found edges which occurred throughout these masses. In straightforward terms, there were four light or mid green tone areas, forming a general arc around the boathouse, behind which was stated a backcloth of the deeper-set wood-land. (It is probably a good idea to condition the mind to assess parts of the subject in these simplified terms. The results of this thinking are

then transmitted through to effective brushwork on the canvas, sensed in a broad rather than too detailed or considered a manner.)

Cadmium red was mentioned earlier as part of the chosen palette for this exercise, and was employed in all the warmer sections. Mixed with ceruleum blue, white and, to a lesser extent, raw sienna or viridian, it proved to be a desirable choice, allying effectively with the cool greens around the surface area.

STAGE 5

The immediacy of technique used so far in the demonstration was overlayed to some degree in this final phase with a consideration of some of the finer detail. Some suggested rigger work from the reed beds in the foreground broke nicely into the water surface, contrasting with the various horizontal dashes of colour which

suggested the floating weed and vegetation. This marrying of the initial rawness of brushwork to these more finished, though economic, statements is the essential visual package the *plein air* painter needs to convey to the viewer. As always, it would have been very easy here to have become so wrapped up in the painting process that one projected the image to too fine a degree of finish, and consequently lost the charm of that instant impression. On balance, I would guess that in this case maybe 50 or 60 per cent of the Stages 1 and 2 surface coverage remained untouched through subsequent applied strokes and passages. That apparently careless, random brushwork finds its true meaning when related to some small adjacent section of a more resolved nature.

I continued to employ these rigger strokes through the upper sections of the subject, producing them with marginally less definition and attention in order to create a sense of separation between the foreground and the woodland sec-

tion. Close-toned, intimate subjects of this kind do require a subtlety of approach to convey a feeling of transition and space in what might easily become a rather flat image, lacking in these essential qualities.

When faced with a subject of this type, offering close tonal shifts rather than much in the way of colour range and diversity, it pays to limit the colour range as suggested earlier and avoid any temptation surreptitiously to add a few little extras as progress develops. Unity is best maintained by the limited, disciplined approach.

This two-and-a-half hours of intense painting experience did, for the most part, live up to expectations. Much of a painting's success or failure is down to the painter's attitude of mind on the day, and to that initial 'gut' feeling about the potential quality of the chosen subject. Before you begin work, there is always that optimistic image in the mind of the finished painting on the board. It might just be that – relatively rare – one which comes off!

CHAPTER THREE

WHEN AND WHAT TO PAINT

THE GIN RACE, COCKHILL FARM
Oil on canvas, 14×10in (35×25cm)

If the painter is prepared to stand the rigours of a crack-of-dawn start, there are many benefits to be derived. The atmosphere and lack of human presence is in itself conducive to creativity, and certainly the light effect and colour intensity will be far more telling than nearer midday. In my experience mental awareness and calmness of spirit is never more evident that at this time of day, providing of course the previous evening's activities did not include too much social involvement down at the local hostelry!

Painting is of necessity sometimes a solitary pursuit. It is, however, nice to get out on occasions to paint with like-minded companions. I have been fortunate always to have had such a band of kindred spirits keen to join me out in the field. Those halcyon days, often at art society weekends, yield their own brand of humour. On one occasion many years ago, whilst I was in the initial throes of that blocking-in stage where the result bears not the slightest resemblance to the subject except, hopefully, in the painter's eye, a child came up and said, 'Are you an artist, mister?' With all due modesty at that time, I replied, 'Well, no, not really.' 'I didn't think you were,' commented the child!

Having to cope with an audience when working outside is, for many painters, an infernal

MIDDAY SHADE, HYDRA
Oil on canvas, 30×24in (74×60cm)

distraction. Most people are understanding and afford your work but a cursory glance. Some are more inquisitive and a real nuisance, destroying the necessary concentration, and they always seem to turn up at the most crucial phase. After long experience, one eventually becomes quite thick-skinned and can almost 'shut off' from the surroundings. One painter I know will not communicate at all – he must seem an unsociable soul to those onlookers. Some are more gregarious, and will happily chatter their way through a painting with no adverse effect upon the end result.

PAINTING
IN THE FIELD

Throughout this book, I emphasise that there is no real substitute for painting experienced in the field, although I accept that many fine results are achieved from sketchbook notes, with considerably less time spent on site. Indeed, there are tremendous drawbacks to being out in the open, especially in the crisp light of dawn, and certainly some painters do not have the available time or physical stamina to cope with this rigorous regime. Of course, if the painter has developed the special skill of transferring minimal information from sketchbook to paint in a convincing way

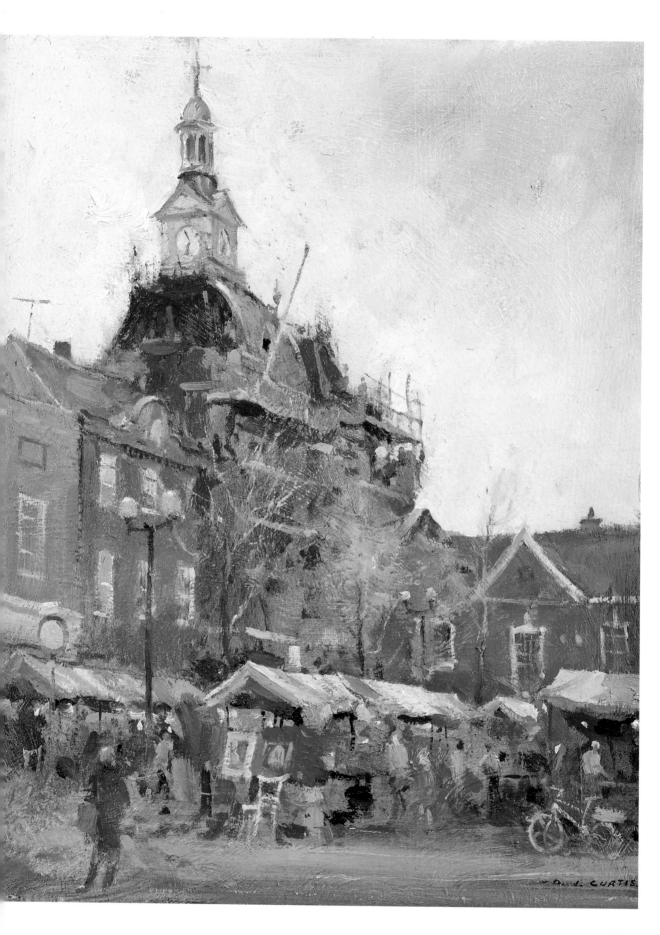

then he or she is particularly well armed for capturing all those fleeting subjects which may present themselves. A good visual memory, and a formidable store of practised techniques for transferring information to a larger canvas can only enhance the overall calibre of the individual.

I cannot imagine a greater satisfaction for the painter than to have a painting or series of sketches 'in the bag' before breakfast. I remember recently catching a few autumn days' painting with a colleague at one of our favourite river venues. Each morning we were able to catch the sunrise and get the best of the day, for on each occasion the pattern of the weather was rain by mid-morning and a dash for shelter. A tactical retreat to the car, and the production of some-thing on a small scale using the *pochade* box, would appear to be the best plan of campaign in this situation.

THE SEASONS

In summer, given the benefit of sunlight, there are perhaps five or six useful hours of painting time available before the sun rises to the extent where shadow length is at a minimum. This mid-day period is often considered to be the least interesting time of day, yet is often the point when most of us find time to work outside. Of course, as the afternoon develops the shadows lengthen again and colour values intensify, and we are back with optimum painting conditions. An interesting exercise is to paint exactly the same subject first in the early morning, and then again in late afternoon. The result is two vastly different canvases, emphasising the fact, men-tioned in the previous chapter, that much can be gained in subject scope from a limited area in terms of locality.

Painting out of doors in summer is a delight. I do not necessarily feel, though, that one's best work is produced when all conditions are favour-able. Maybe there needs to be an element of the 'fight' – the struggle against the elements – to engender that little extra drama in the finished result. Winter painting, giving a predominantly low sun, ensures that the whole day is of consis-tent quality and interest, and yields a tone and colour range devoid of all those strong greens of summer which can be the cause of so much diffi-culty. Greens are so often overplayed, and here again the restrained range of colours, outlined in

Chapter 1, becomes instrumental in maintaining some control over proceedings. There is, perhaps, more eye appeal in a winter canvas of the warmer hues offered by that season – those lovely, subtle browns, ochres and purples seen in the landscape as a whole.

The trials of winter painting on site are far outweighed by the special quality which exudes from the canvas, whatever level of skill the painter has reached. Maybe it is the tone and colour balance, or quite simply the charm of the landscape when at its seasonal rest. The presence of snow presents a special challenge, usually offering the choice of a cooler palette, the en-forced simplification of shapes and, as a result, a golden opportunity to search out a real feeling of design quality from the subject. As painters, we become fascinated by the play of shadows cast in steely blue across a snow-laden expanse, the purple-grey stand of trees contrasting starkly with the foreground features – so many exciting variations to the landscape occur with the onset of snow. In fact by utilising the seasonal changes, as well as the diversity of landscape character which can often be found within a relatively small area, it is possible to extend the scope of your subject matter greatly and provide fresh stimulus without having to travel huge distances.

One particular painting friend of mine, a hardy soul, likes nothing better that to paint out-side when the snow arrives each year. Preferring to observe the landscape more acutely by bicycle, he has produced over the years many stunning little canvases in such circumstances. Travelling home from a painting venue at dusk one frozen winter's day in the warm security of my car, I spotted him outside his house perched on his bicycle. Stopping to enquire as to his wellbeing, I found him virtually frozen to his steed and having great difficulty dismounting! A warm fire and a shot of rum soon thawed him out and the super painting resulting from his labours was perched on the mantlepiece for our perusal – what lengths some artists will go to for a subject!

LOCATION AND LIGHT

We all have our favourite locations which are visited often. It can become a safe option – we are familiar with the area and might feel assured of a greater success rate in our painting. Some people find it frustrating to work in unfamiliar territory and there is no doubt that it can often

THE FRIDAY MARKET, RETFORD
Oil on board, 10×12in (25×30cm)

THE SADDLING ENCLOSURE, DONCASTER
Oil on canvas, 30×24in (74×60cm)

take some time to get used to it before any reasonable result is achieved. The individual character of the place needs to be sought out, and this frequently requires some modification of one's usual approach. I particularly enjoy the discovery of a new venue and find that the stimulus of this overrides any fear of early failures, even though they can and do occur. When away on a painting trip, there is always a feeling of relief when the first painting is completed, be it success or failure, and quite often when the work is viewed later back in the studio, it is that initial piece which has the most to say.

Apart from the changes in terrain and architecture and all the other elements which make an area unique, it is the variation in the quality of the light in different locations which can be so arresting. To be faced with such a range of light conditions during a painting year gives me, at least, a sufficient sense of visual anticipation to allow the whole adventure of painting to remain a driving force in my life.

TOWNS AND CITIES

If the painter is not afraid of the more complex subject, then the townscape or cityscape yields quite memorable potential. Viewed intimately or as a panorama, the bustle of city life with its elements of transport, figures, architecture and so on have always fed the artist with a wealth of creative possibilities, and practically every city on earth has been represented by important paintings by a succession of major artists.

In these upwardly mobile days, it is now assumed that most painters, amateur or professional, will travel as a matter of course to far-flung places searching out the most 'paintable' of the world's cities – Paris, Venice, Rome, Vienna and New York to name but a few of the most obvious. To this end, the organised painting holiday has reached increasing heights of popularity over recent years. Well advertised and structured, they offer a meeting place of like minds in a visually receptive location, usually under the capable direction of recognised professionals. Many students return burning with enthusiasm, and may try several tutorials in one year. Amusingly, it is often easy to spot the work produced by these students – it usually bears an uncanny

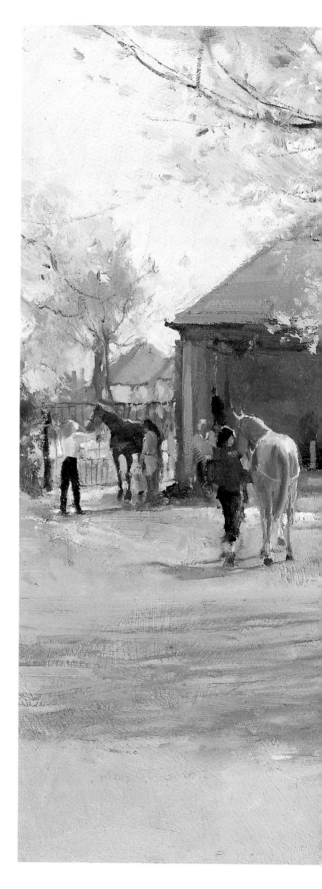

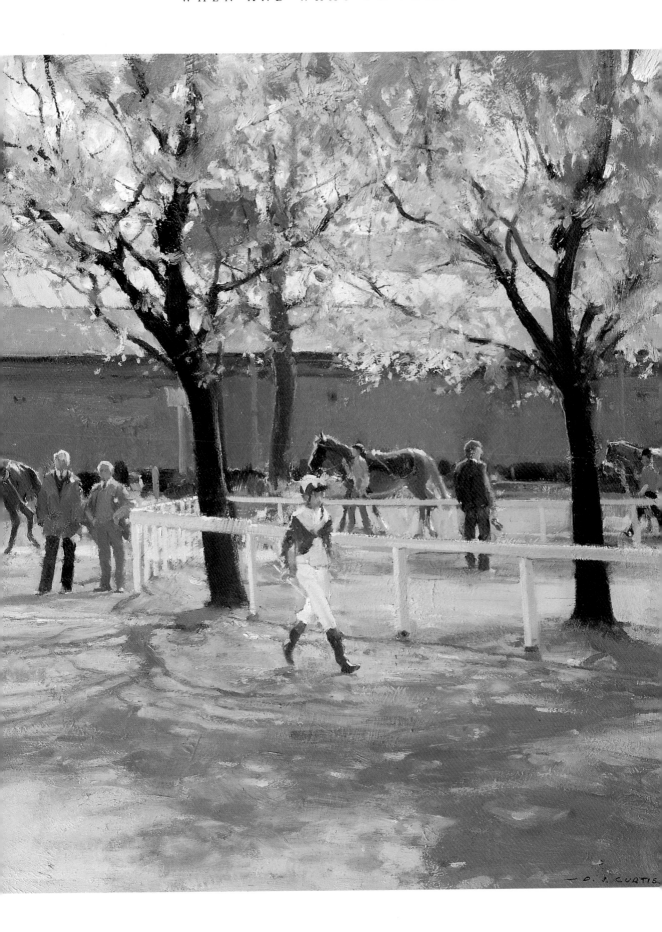

resemblance to the techniques used by the tutor! This is no bad thing, however, for eventually the mark of the individual resurfaces, and with luck the best of the tutor's guidance is soaked up and is manifested in the student's own individuality in the longer term.

Painting early and late in a city or town environment allows full use of the play of shadows. Most fascinating is the effect of buildings in half-shadow. Here, the lower half of the canvas can be a diffused series of darker tonal elements, with the activity not overly stated at street level, and the strongly lit shapes of the upper part of the buildings are then allowed full effect.

Since the city is a daunting environment for the painter, full use of the little *pochade* box can be most effective and one can appear quite unobtrusive tucked away in a quiet corner or doorway. I found this system especially useful a few years ago, when faced with the prospect of several days' painting in the centre of New York. The vision of shadow, sun and street activity have particular significance in this whirlwind of a city.

Once again, consideration of the high and low viewpoint is instrumental in specific subject attraction. When in a city environment, I always try if I can to gain access to the obvious high buildings in order to see if some really special subject might be forthcoming. The most exciting example of this was when I painted the view of Venice's Santa Maria della Salute from the Campanile tower at dusk. Here was a composition of quite outstanding appeal where, with the light beginning to fade, the shapes became simplified whilst at the same time offering the most stunning design of aerial perspective, with the Santa Maria della Salute complex in the foreground and the gradually receding island shapes interweaving into the distant pink, milky light of the industrial north beyond the city of Venice below me. This occasion was a real one-off – and became a visual experience which was etched in the mind for life.

WINTER OVER HARWELL
Oil on board, 16×12in (39×30cm)

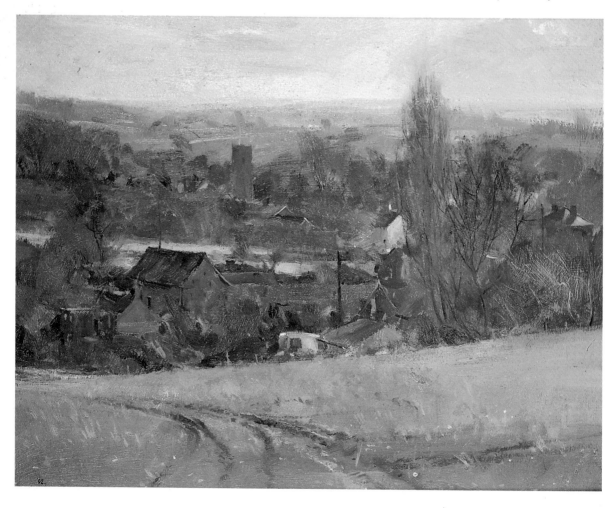

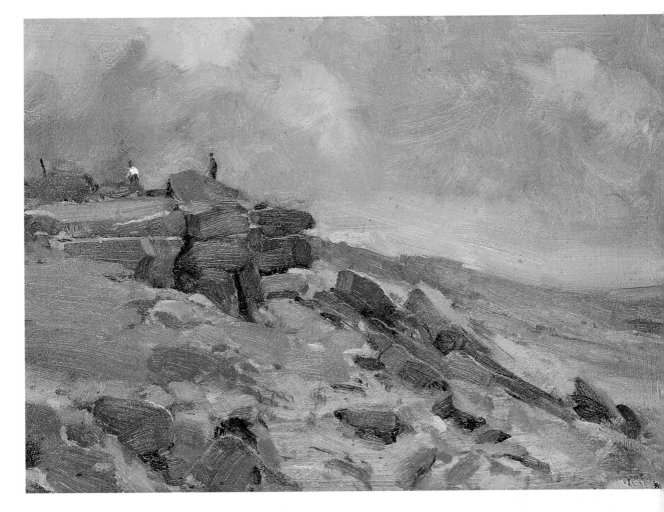

LAND AND SKY

To ring the change from all this, the flat, some-times featureless terrain can, on the face of it, appear a little uninteresting. Here the accent is placed on a low horizon, with the land mass but a foil to the dominant feature of the sky form. Sir John Arnesby Brown and, once again, Edward Seago were two fine exponents of sky interpreta-tion. Painting regularly in their native Norfolk, they were presented with the broad, open land-scape and would pitch the horizon low in order to concentrate on all the variations of form the skies offered in that region. In fact, Seago is known to have been attracted to skies as a small boy during long periods of illness, when of necessity he would have to lie in bed and observe this part of the landscape more than any other. It must have been this which taught him to see so acutely the way in which clouds are formed around their many variations of mood, through the changing weather patterns. The results of these studies were, in his mature years, to demonstrate that great understanding which

BURBAGE – THE NORTH
EDGE
Oil on board, 14×10in (35×25cm)
This Peak District gritstone escarpment provided the subject matter for the day's outdoor painting exercise – a simple study of tone and atmosphere produced on a cold, windswept location. Not everyone's idea of a pleasant weekend activity, but worth all the discomfort if you come away with at least a semblance of a satisfying result.

became one of the strongest and most easily recognised hallmarks of his art.

It takes a particularly long time to find a technique which convincingly portrays the sky in all its moods. The study of the fleeting moment is, in many ways, as much of a discipline as attempting the 'shorthand' technique for the moving object or figure. What is required is the ability to be selective in what is presented as an image – to retain the best in your mind, and transfer that feeling speedily to canvas. What is often lacking are cloud formations with any degree of convincing form, but once this form is understood a series of subtle tonal mixes can be utilised to effect the conditions which prevail

WATER MEADOWS, MISSON
Oil on board, 14×10in (35×25cm)

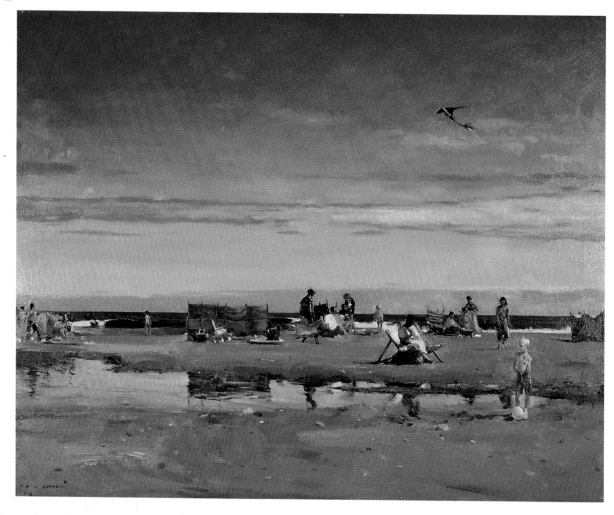

THE KITE FLYER
Oil on canvas, 30×24in (74×60cm)

very quickly. Incidentally, a generally safe ground rule is to appreciate that the intensity of a blue sky is always up towards the zenith, and that the blueness is tempered with more yellow ochre and red, maybe, as the area recedes towards the landmass horizon.

LANDSCAPE CHARACTER

Most of us, if asked, would state an affinity for a specific type of landscape character. For me, one such area exists in the Derbyshire Peak district. Here, a wide variety of landscape characters is combined in a relatively small area but, even with the variations, these elements are clearly identifiable as only of this area. Rough gritstone escarpments and tors, stretching for miles, flank deep wooded valleys around Sheffield, contrasting with limestone country to the west and south, while the highest reaches offer bleak, forbidding moorland – the preserve of sheep and shepherd and the more hardy weekend walker.

This has always been the most convenient bit of hill country for the numerous painting ventures I have engaged upon over many years of working out of doors.

ROCKS AND MOUNTAINS

An introduction to the higher mountain regions was initiated on painting excursions to the Lake District and Scotland. I slowly became fascinated with the structure of rock formations, where great buttresses of granite appeared as guardians of the valleys, whilst normally they tend to be painted as a more generalised feature of the whole landscape. I developed a desire to produce designed compositions, working much more closely to the actual structure of the rock. Having been tempted into hill walking and climbing, the total experience of sampling that controlled physical buzz of movement on rock in

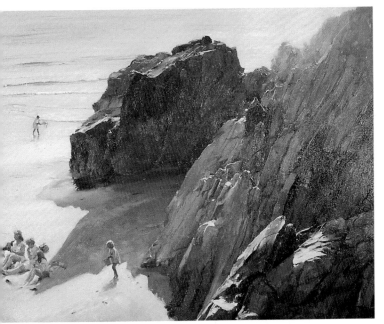

THE PICNIC PARTY, GAIRLOCH
Oil on canvas, 30×24in (74×60cm)
The high viewpoint here offers large, strong areas of form within a rather diffused, milky afternoon light – lots of scope for the observation of reflected light passages in soft ochres and blues.

KERN KNOTTS, GREAT GABLE
Oil on canvas, 40×30in (98×74cm)
The monumental structure of this Lakeland crag is a study in gently changing tonal passages of subtle greens, ochres and grey-purples. The deep-set crack lines give form to the complete shape and lend an overall sculptured feel to the piece. Incidentally, a few years after this was painted, the hard winter frosts got to work on the less solid-looking rocks on the right-hand side and a large proportion broke away, plunging down into the valley many hundreds of feet below.

EAGLE'S NEST RIDGE DIRECT
Oil on canvas, 40×30in (98×74cm)
Having experienced the drama of serious rock climbing excursions on many occasions, and in terrain like this, I eventually felt the need to convey on canvas an impression of the degree of mental and physical commitment faced by the climber in these situations. The dark, plunging rockface, with all its cracks and fissures, stands in sharp contrast to the mountainside across the valley, painted in a very high key and suggesting an especially airy feel to the place, achieving as a result the intended feeling of awesome exposure!

BEACH FUN WITH EMMA
Oil on canvas, 16×20in (39×49cm)
Here is an attempt to capture that 'movement of the moment' and the age of innocence in a single image. The child dominates the composition, placed just left-of-centre, with the other figures assisting the perspective and breaking the continuity of the distant horizon line.

a vertical or near-vertical environment and then experiencing the aesthetic need to convey some of that feeling on canvas, led to a series of climbing paintings, produced in the 1970s and early 1980s.

By alternating one day's climbing with one day's painting, the hard physical and mental pressure of the climb balanced the painting experience in such a way as to generate an awareness of subject and calmness of spirit conducive to a positive result – a profound feeling and unique, for me, to this dual experience of the mountain regions.

COASTLINE AND BEACHES
Endless possibilities for subject material lie along our coasts. From the vast expanses of beach, where leisure and sporting activities of all kinds abound, to the ports and harbours illustrating a diversity of the working environment, we can select material with potential. So often, coastal subjects are seen from a broad, expansive viewpoint and at a distance. For me, the most exciting possibilities lie in the more localised aspect, fre-

quently seen at close quarters, with the accent placed on careful design elements and striking light effects, often looking deliberately into the sun.

I have for some years been fascinated by wet sands at low tide and the effect of figurative content on this surface. *Beach Fun with Emma* is one of a series on this theme. Here I looked for strong form in the foreground and, in order to give a feeling of perspective and space, placed various groupings of figures in the middle and far distance. The close tonal values of the sand, affected by the receding tide and play of light, serve to give a placement for the figures, as well as an ever-changing surface effect as the figures recede through the composition. Once again, a

high horizon assists the feeling of space. You will see that I have cut objects into the horizontals to break the continuity of line, ensuring that the main subject figure is placed off-centre and adhering to the Golden Section principle, with the canvas area split into the favoured one-third sections.

In the search for alternative structural content in coastal painting, the harbour site with all its colour and form offers considerable scope in design appeal, especially if the more localised viewpoint is considered. Fishing boats tied together in sheltered moorings, vessels in dry dock exposing the full effect of their construction, and the working figures which give life and action to the scene, are all a feast for the painter's eye and

offer an alternative to the more traditional coastal landscape.

The most dramatic natural form along any coast must be the sea cliffs. Several of the paintings reproduced in this chapter demonstrate the

EVENING LIGHT, ARISAIG
Oil on canvas, 30×24in (74×60cm)
These beachcombers are carefully placed to provide the best compositional option for the subject. It is often a good idea to place a figure against a dark object if there is a possibility of capitalising on the light peripheral edge, as can be seen with the fair-haired girl on centre. The counterchange then lends a feeling of space to the scene. The long evening shadows provide a sort of simple abstract design reserved for the foreground area.

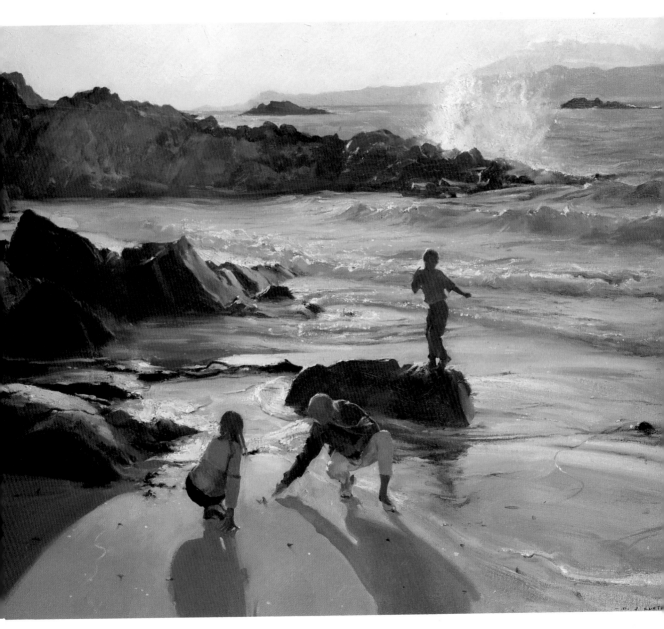

BEACH AND CLIFFS, TORRENT DE PAREIS-MAJORCA
Oil on canvas, 30×24in (74×60cm)
From a half imperial watercolour, produced on the spot,
this dramatic composition was later worked up in the
studio. The appeal of the subject lies in the comparison of
such vast tonal and textural changes, while the effect of
counterpoint is shown in a forceful statement of simple light
sections and strong darks.

variations in character which the introduction of this powerful element can evoke in our work. The very strong, simplified shapes act as an effective backdrop to the other points of activity, employed to make up an interesting composition.

INDUSTRIAL LANDSCAPES

Evocative images for the painter have always been drawn from our industrial heartland. Not here the tranquil beauty of pleasant rural greenery, rather a more sobering view of man's working environment. Subjects with a powerful message can be extracted from the factory complexes with their tall chimneys and the smoke-laden industrial valleys – perhaps not very saleable, but nevertheless a portrait which some of us find it necessary to convey. These days, however, this image is less in evidence – some would say thankfully so – and has been replaced by the atmospheric stillness of the industrial wasteland. Living close to one such area, this image has formed some of my subject material over the past few years (see opposite). I believe it is the painter's duty to attempt to convey not only the niceties of the landscape, but also that which is less appealing, 'warts and all'.

RIVERS

The river offers universal appeal. It threads its way through all types of landscape, including all those variations we have mentioned, and is, in its own right, one of the most frequently used focal points in landscape painting. Be it tidal or fresh water, the river's varied moods yield challenges in texture, tone, colour and reflection to stimulate the eye. One painting group I have the pleasure to be associated with draws its material exclusively from all aspects of the River Thames as it winds its way through London and beyond. The Wapping Group of Artists meets for regular outdoor sessions and, since the vast proportion of the group's output is more or less completed on site, the resulting annual exhibition conveys a freshness and immediacy of execution which is most appealing. Compositions range from the

CANAL WHARF, SHEFFIELD
Oil on board, 16×20in (39×49cm)

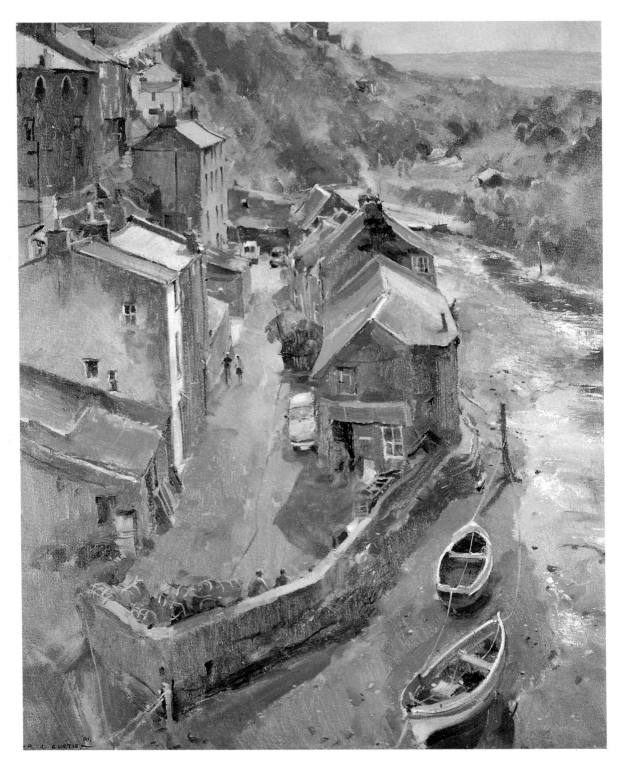

familiar landmarks of central London to the further reaches of the river, although even here the degree of shipping activity and general subject content so evident in the old days is now in short supply. This carries the risk of producing apparently 'empty' paintings, so taxing the group's inventive skill to produce work of lasting appeal.

RIVERBED, STAITHES
Oil on canvas, 10×12in (25×30cm)
Using the high aspect to accentuate a feel for design, this 'S-shaped' composition is a complex though loosely described piece of work. It was carried out on three consecutive afternoons, utilising a similar three-hour period on each of the days in order to gain the benefit of similar light conditions. The smoke trail and little groups of figures add activity to the finished piece.

OLD HUMBER BARGES
Oil on board, 18×24in (44×60cm)
*Strong directional lines and the effect of a low winter sun
are the essential ingredients in this barge repair-yard
scene. The dark areas are placed well down in tone in
order to throw extra emphasis on the parts of the vessels
receiving accents of light.*

THE GIMBLET ROCK, PWLLHELI
Oil on canvas, 20×24in (49×60cm)
*Produced entirely on site, this subject was a must.
Essentially it comprised three simple tonal shifts of dark,
mid and light in broad blocks, encompassing
the whole canvas.*

HARBOUR STUDY, STAITHES
Oil on canvas, 10×12in (25×30cm)
The fishing village of Staithes often looks its best in an early morning light. This oil sketch was executed rapidly – in about an hour – in order to make maximum use of the shadow forms. The subject is an exacting exercise in matching section to section, and in employing the discipline of not resolving any particular area in too much detail.

STEP-BY-STEP DEMONSTRATION
SANDBECK HALL

When faced with an architectural subject of this type, the painter is often tempted to view the entire building 'face on', and the resulting over-involvement with the complexity of the drawing can eradicate any spontaneity which might be achieved in the time available on site.

Here, this fine old hall appealed from all viewpoints. I finally chose just one corner of the building, highlighting the pillared facade, based on two main considerations. Firstly, there was the opportunity to utilise a strong feel of perspective when viewing from this angle, and secondly, I liked the idea of the light through the pillars punctuating the overall mass of the building.

The day was cool and windy, with an unsettled air about it, though some limited evidence of the sun appeared from time to time and it was a question of capitalising on any shadows offered through the painting period. I saw the image pre-

sented on a vertical format with the horizon probably on the lower Golden Section, this low aspect lending an agreeable feeling of height and substance to the building.

With the weight of the composition tending towards the right-hand side, some feature would be needed to counter a possible imbalance. Often a quite minor shape or form can satisfy this requirement, and here the plinth and urn achieve the desired effect.

STAGE 1
I selected a 16×12in (39×30cm) Gesso and texture-paste primed board with a previously applied wash of french ultramarine and burnt sienna, now fully dry – a surface, hopefully, in accord with the subject to hand.

First, the broad, directional lines suggesting

STAGE 1

the optimum compositional layout were applied. Essentially, the idea was to provide strong horizontal and vertical emphases which would then be linked by other attendant forms and shapes, thus generating a firmly structured basic image from which the blocking-in stages could be assessed. The wide pathway provided an effective 'lead-in' to the steps, these in themselves being an important horizontal feature, linking the mass of the building to the small vertical plinth feature on the right. An initial note was made of the dark archway to provide, possibly, a point of focal interest as the painting developed. Even at this early stage, it can be seen that some form, perhaps figurative, will be needed to break the horizontal block of the stepped area.

STAGE 2

Observing the scheme of things as a whole, in a tonal sense, I immediately noted that there was a weight of cloud formation predominantly in the area above the building, with a lighter bank at mid distance. By the same token, at foreground level there appeared a generally shadowed area striking across from right to left, with a light band emanating from the right-hand edge of the lower Golden-Section horizontal. The preservation of both these light passages would, hopefully, serve to surround the building and emphasise the sense of drama which could be brought out from the subject. In simple terms, there is in essence a dark mid-tone block for the building, cushioned from above and below by a light mid-tone block, sandwiching an area of quite light tone in the middle section. This play of light, I hoped, would turn out to be the key appeal of the work.

This brushwork was then speedily put in place on the board. Ceruleum blue, raw sienna and cobalt violet were the main ingredients, along with titanium white, for the sky area, all the mixes adjusted so as to give a feeling of aerial perspective. Winsor lemon, raw sienna and viridian with white were applied in the foreground area, with ceruleum blue and cobalt violet included for the near foreground shadows. To separate these areas, a good strong, dark area was suggested for the hedging and the stepped area. French ultramarine and raw sienna with the viridian satisfied this section, with only a little white added.

With a fair idea of the extremes of tonal range now established, the distant band of woodland could be suggested in true register with the adjacent passages. Ceruleum blue, raw sienna and cobalt violet, with a fair degree of white, was

STAGE 2

used in an attempt to pitch the tone and colour as faithfully as possible. Sometimes, even at this early stage, certain passages give a feel of having been placed quite effectively, even in this broad, random way. Should this happy event occur, it is best to leave well alone. In this case, I felt that the tree area just described fell into place quite effectively, and so was inclined to leave the statement relatively untouched through all the subsequent stages.

Finally, a little warmer tone was suggested for the vegetation appearing up the front of the pillared facade to complete Stage 2.

STAGE 3

This stage concentrated almost solely on the tonal values of the building, in an attempt to create a register between it and the surrounding light and mid-tone passages. Although the sun slanted from the top right-hand corner of the subject, some examples of reflected light appeared in a diffused manner on the front face of the building and on the face of a building on the

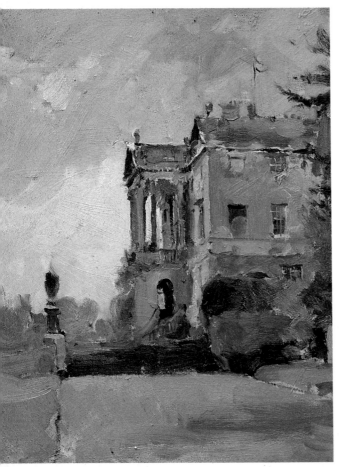

STAGE 3

the extreme right-hand side foreground building edge. Its shape was broken by the fir tree cutting into the image, transferring the eye back towards the central area of interest.

An indication of the flagpole served as a useful minor vertical, and the later indication of a spot of bright colour on the flag added a little interest and movement to the subject. It was also a nice echo of the vertical plinth, appearing at about the same distance in from the left-hand edge as the plinth's position from the right-hand edge. This Stage 3 working achieved full coverage of the surface area of the board.

STAGE 4

I now turned my attention to the tonal relationship of the various blocks as they met each other. If correctly assessed and balanced, a convincing feeling of space and distance could be achieved. In particular, the grassy slope to the left of the plinth and urn was worked quite light in tone against the wooded backcloth, an indication of the cast shadow of the plinth suggesting the slope of the lawn. A little firming up of the lawn edge on the far right was noted, along with a strengthening up of the path edge on the left to add more form to the foreground area and convey the eye up towards the focal area.

Next, a top light was added to the steps in order to break up this rather insistent mass. Some attention was given to detail around the archway below the pillars and immediately above the steps. A few simple, warm strokes cutting into the sky extended the vegetated area at this point, the general warmth contrasting with the coolness of the wall surrounding the archway. A suggestion of a carved stairway leads up to the arch and is a nice, subtle continuation of the foreground steps. The warm red of the flag was stated and the foreground urn was painted with greater accuracy of shape.

The completion of this stage took about two hours. It was interesting to note that at this point, when the sun shone through the clouds the highlights on the building seen at the commencement of the painting time were now no longer in evidence. These are essential observations and have to be stated immediately as seen; as a consequence, they add a heightened feeling of life to the finished piece.

extreme right-hand side of the board. The use of this effect assisted in the interpretation of the form. Furthermore, I noticed some glancing lit edges on the rare occasions that the sun blessed the day with its presence. Whenever in evidence these were quickly stated.

In the main, the broad blocks were solidly placed, using the subtle variations of local colour, whether warm or cool, to make up the total impression of the building's character. Emphasising the darker tones around the pillars gave an effective impression of the light which appeared through these gaps. French ultramarine, burnt sienna and raw sienna with white achieved the switch from warm to cool tonal value necessary for this overall mass.

Some careful observation of the window form and structures was taken into account, noting the two 'taxed' windows on the wall facing the viewer which lent a change in texture compared to the glazed windows to their right. A dark mass was stated for the plinth and urn remote of the building, as was some indication of

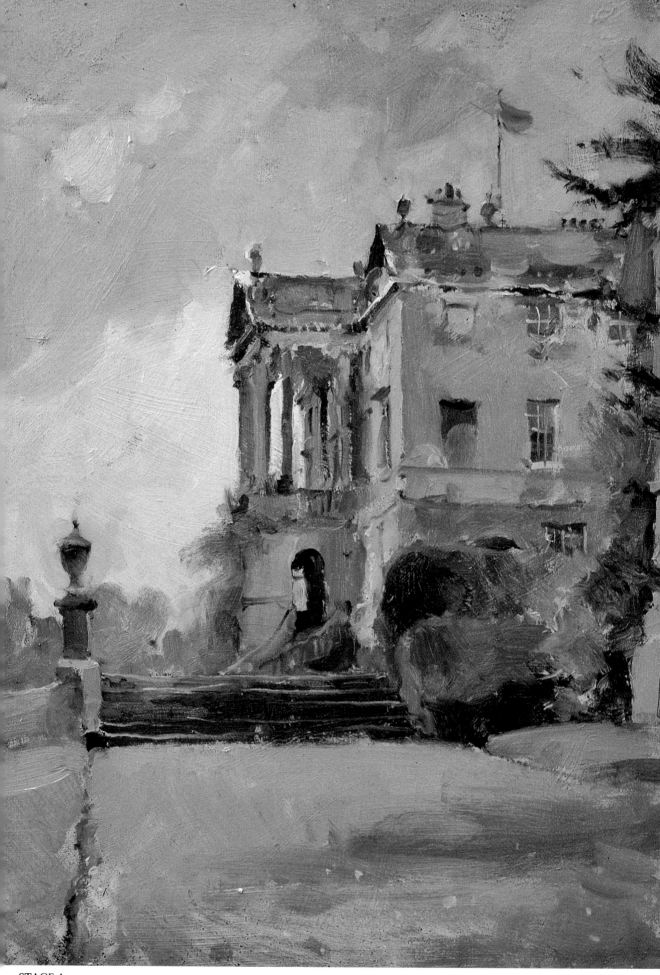

STAGE 4

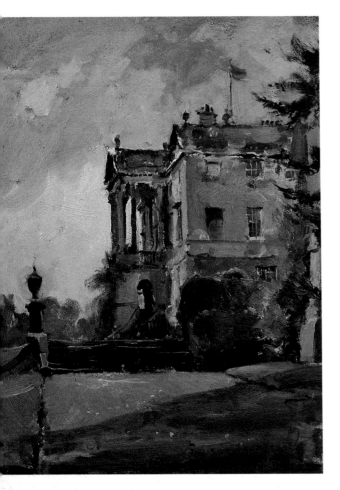

STAGE 5

STAGE 5

At this stage, I was a bit concerned by the lack of shape and form in the foreground, and felt it would be advisable to make the most of any shadow striking obliquely across the pathway. The sun appeared weak and fleetingly, though just enough to make the statement of the dark tone. Once stated, it seemed in itself a little solid, flat and unconvincing, even though it provided the cushion or base from which to draw the eye up to the middle section.

STAGE 6

I now carried out a degree of 'softening up' of the rawness of the sky brushwork just to reduce the hard edge and make the area a little less insistent. With the sky tone on the brush, some important structural edges of the building were now defined more clearly, on the basis of using light cutting into dark rather than the reverse in order to create a feeling of space behind the mass. Some suggested architectural detail, but not too much, was tentatively placed – carefully ob-

served, but speedily stated. It is probably true to say that in general, observation time is far greater than actual painting time. I thought an accentuation of the flag colour details would be a nice touch, so these strokes – one white, one mid-red and a red of a lighter tone – were then spotted in with haste.

Feeling the upper section of the painting was now reasonably soundly stated, I was still unconvinced of the effectiveness of the lower part. Round about this moment of unease, sunlight suddenly appeared for more than its customary thirty seconds – sufficient time, in fact, to observe a rather attractive filtered light on the hedge and bush and a more defined, strong light striking through the gap between the buildings. This was the make or break opportunity I had been waiting for. Redressing the foreground shadow area to a more broken shape, and with more warmth in the mix, it was possible to force the light on the grassy verge and on its consequently warmer continuation on the pathway. Highlighting the top edges of the hedge, and building some light textural form into the bush area, helped to create a space between the nearest building form and the main structure some yards away. I was now happier with the outcome of this adjustment phase.

A carefully positioned figure did seem at this stage to be necessary to achieve the final effect. The walking figure just off-centre to the steps serves to break the horizontal and lend a sense of scale to the composition as a whole. He is loosely stated – I think it is important not to paint these figurative statements in any more detail than that of the overall subject. The figure then appears as part of the whole and not as an afterthought.

This three-hour demonstration was an exercise in the marrying of strong architectural form with an often fleeting light effect in order to create, hopefully, a satisfying image of tonal unity, with some tenuously repeated motifs and cameos.

STAGE 6

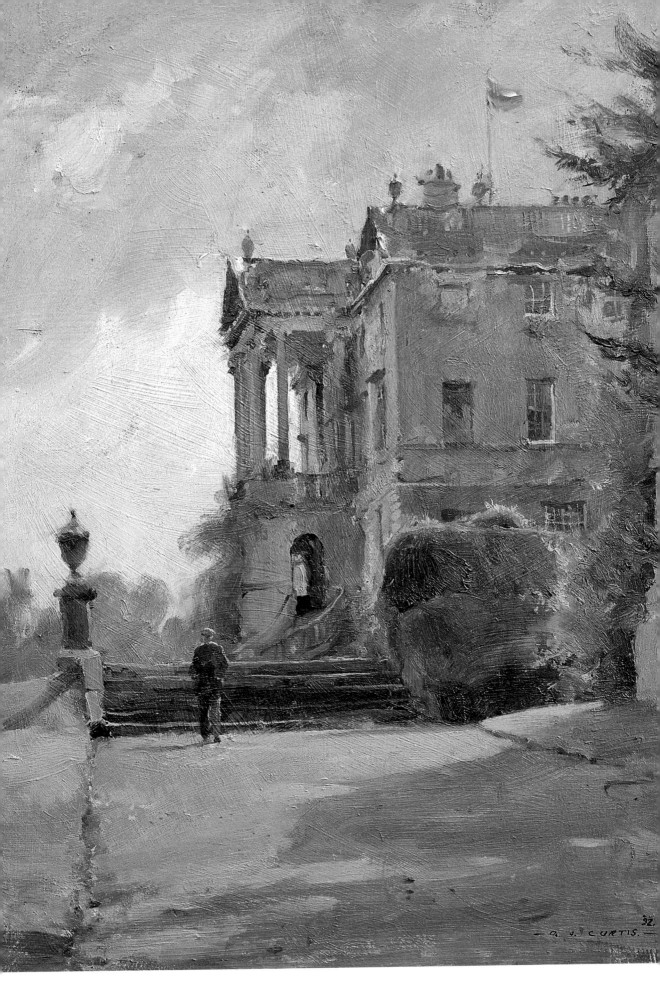

CHAPTER FOUR
FACETS WITHIN THE SUBJECT

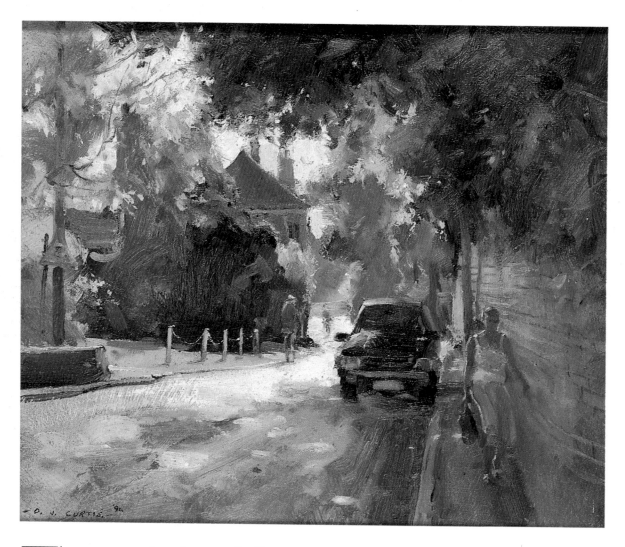

AN AFTERNOON WALK, ACKWORTH
Oil on board, 10×12in (25×30cm)
Here, the use of vehicles and figures adds interest to what might otherwise be quite an empty painting.

There can sometimes be a small effect or detail in a picture which is especially appealing and enhances its total effect for the viewer. It may be some acutely observed cameo within the canvas area, borne of figurative content, or perhaps a special effect of light. Whatever it is, it projects the finished work from the merely average to something rather special.

Within the realm of landscape, some repeated motifs or examples spring readily to mind which are often seen in appealing works. They might include reflected light passages, reflections, smoke, figurative groups – in fact anything which contributes life and sparkle. The inclusion of aspects of life and form once again require a good degree of drawing skill. Figures, cars, boats

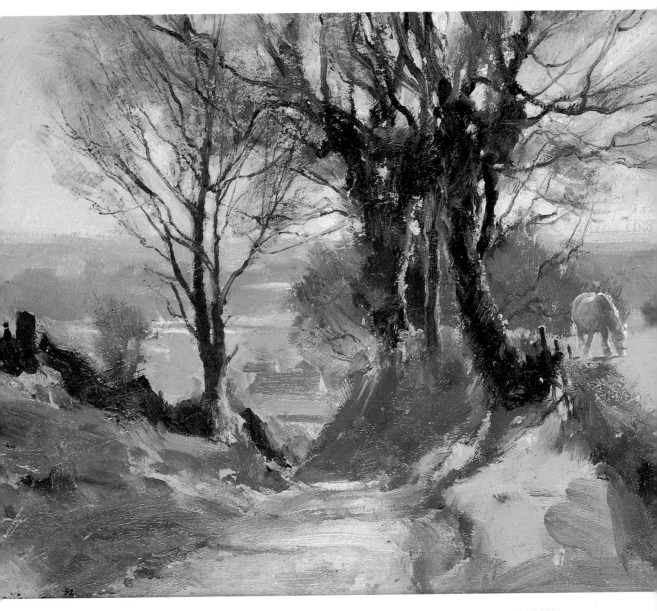

and so on make bold contributions to any paint-ing and, if badly painted or introduced without a surety of touch could easily have the reverse effect, destroying the life and charm they might otherwise have created.

USEFUL DETAILS

Using trails of smoke from bonfires or chimney pots seems to add a feeling of life and activity to the scene. The technique needs to be carried out with subtlety and be a tentative understatement, rather than appear as the result of a major con-flagration. It can be used to break up a simple area of tone, or, dare I say, to obliterate a rather difficult passage in the painting! A mix of titanium white, ceruleum blue and light red can

LANDSCAPE OVER CARLETON
Oil on board, 10×12in (25×30cm)
Loose brushwork, with the strokes trending upwards and outwards, generates a feel of growth in the trees and avoids that stunted look so often associated with their treatment by the beginner.

quite often hit the correct smoke colour, inten-sifying the white towards the source of the smoke plume and feathering off the effect as it progresses upwards and outwards.

In line with the thinking that what we pro-duce now should be identifiably of our time, I believe we should not shy away from including modern-day transport in our work. Vehicles can be a very useful compositional asset. They need not be faithfully reproduced but merely appear

STONE VALLEY
Oil on canvas, 18×14in (45×34cm)
The attractive twist in the pathway leads the eye nicely
through the composition. The tree forms are treated in a
variety of textures and degrees of tonal weight, to suit their
individual placings in the composition.

as points of interest, loosely but convincingly stated, on roadways and verges. Along with figures, they have the added benefit of establishing scale for all the other elements in the finished piece.

BROADER BLOCKS

Most aspects of the landscape, other than these localised facets, are seen linked or fixed in broader tonal blocks — wooded hillsides and stands of trees, for instance, are observed with slight tonal shifts to convey varying textures within the total scheme of things. Sometimes, of course, trees appear in isolation from the mainstream of the subject and form an integral part of the composition.

In varying character, and through the seasons, trees invariably form the core ingredient of the landscape. Such is their diversity of character and setting, in fact, that the interpretation in paint is too often generalised and the concentrated observation of the individual example is less than convincing. A common fault in the beginner is a tendency to paint trees which give the impression of stunted growth. It is a sound policy to allow a tree its full height and, if necessary, project the image to the top of the canvas, thus enhancing its majesty and presence.

LEAD-IN FEATURES

When viewing the landscape in a broad sense, perhaps the most effective linking elements — those which can be utilised as 'lead-in' features — are rivers, hedgerows and stone walls. Each in its own right makes a major contribution to a well-designed composition if assessment, and sometimes a little modification to the exact reproduction of what is in front of the painter, is employed to best effect.

A Corner of Malham uses much of this thinking. A network of stone walls zig-zags up the hillside in the middle distance, some lines

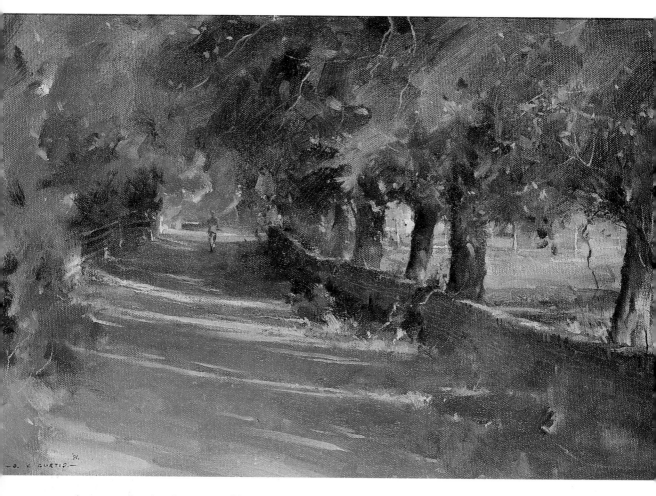

RIVER LANE, MISSON
Oil on canvas, 20×12in (49×30cm)

tending to echo the direction of lines in the foreground section. In this instance I have allowed the tree forms to project to the canvas top edge. This assists the overall 'containment' of the composition and allows the eye to settle around the central shape of the whitewashed cottage wall. The footbridge is designed to lead the viewer towards the figures and thence on to the central focus area. A stream emanates from beneath the bridge and transfers the eye across the canvas; it is stopped on the left by the broken stone wall, its planning and shape moving the eye back to the central area. All these linking or repeated motifs give both structural and tonal unity.

COLOUR AND RESPONSE

Beyond these tangible elements, which are used to generate a well-formed image, there is the more tenuous contribution of colour subtlety and emotional expression. For a painting to be wholly effective it should evoke an emotional response in our audience. In this visual world there are specific colours or combinations of colour which may readily be associated with a particular mood or emotion, and the odd thing is that although we all see colour in slightly different ways, this mood/colour association is common to us all, painter and non-painter alike. It provides painter and viewer with a sort of bridge – or common language – which the painter can use to communicate his feelings and emotions to his audience.

By listing a few of these moods we can then try to express these in colour and relate these, in turn, to their association with the landscape.

Elation, joy: Light colours (tints rather than shades or hues, evoking a sense of airiness); all colours quite close (harmonious) in tone; warmish, but more towards the pinks or pale oranges than red.

Applicable to some beachscape passages, generating a feel of sun and sand and the holiday mood – a bright, fresh, spring day.

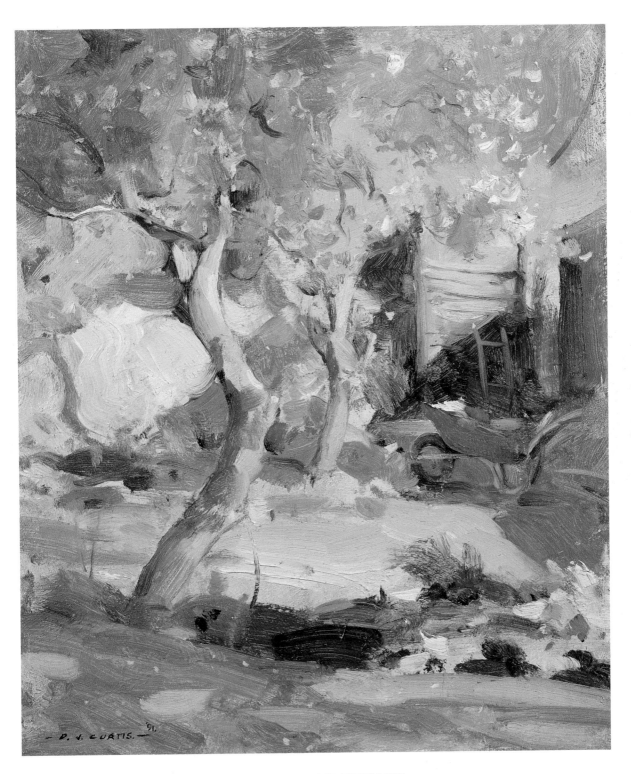

APPLE BLOSSOM, SLAYNES LANE
Oil on board, 10×12in (25×30cm)

RUINED CROFT, KILLEAN
Oil on board, 10×7in (25×17cm)

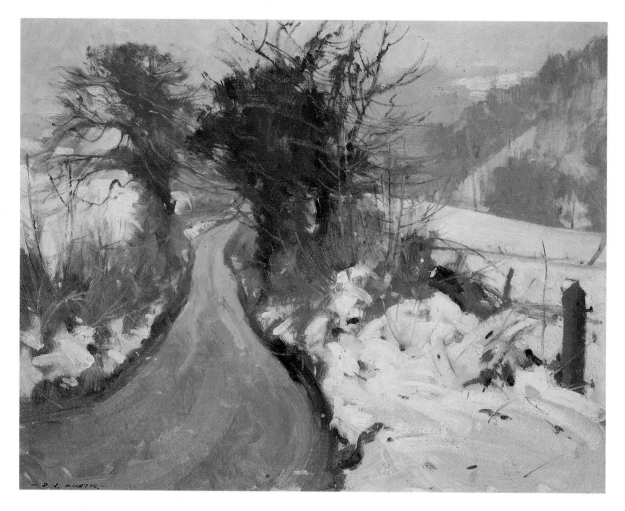

MIDWINTER, RED LANE
Oil on board, 16×20in (39×49cm)

Sadness, loneliness: A grey mood this one, so greys, perhaps a muted black and dull grey-brown; hue weak and vague, large areas of close-toned greys; a long horizontal shape of deeper grey, not quite black, to give weight to the base of the canvas area. Applicable to bleak moorland, industrial wasteland and an overcast, lonely beach.

Excitement, thrills, energy: All the colour contrast we can muster for this one: how about colours which are quite different in hue and different in tone, a sort of 'jazzy' colour combination? Maybe the fairground study – a riot of non-harmonious colours with suggested elements of pure abstraction.

Doubt, fear, anxiety; a sense of mystery, eerie: No contrasts here, a vague indeterminate mood, so deep colours, mid-dark to very dark; very close in tone with tonal similarity, close enough to play down any difference in hue. Applicable to deep-set woodland and the exterior to interior vantage point, suggesting atmosphere within.

Drama, arrogance, aggression, conflict, fury: Very strong contrasts – the contrast of dark and light rather than chroma or hue. Maybe at both ends of the tint/shade scale, missing out the middle values. Possibly applicable to groups of figures in shadow, a larger grouping en masse, storm-laden skies.

Shock, impact, surprise: Pull out all the stops for this one, but be crafty with it – colours are needed which have the maximum effect on each other (the complementaries), and if the chroma shift is to achieve shock and impact then they must be fairly close in tone. Subjects painted *contra jour*, stunning light effects, silhouetted figures with lit outer edges, sunlight flashes on water surfaces.

The intensity of colour has a bearing on the ultimate mood the finished painting creates. We have all seen paintings of 'autumn' – a subject beloved of amateur painters and professional

artists alike – paintings made up of fiery reds and sulphurous yellows, creating an effect that completely ignores the fact that autumn is the time when the year has spent its energy and is settling down, resting before the rigours of winter set in. Colour is certainly there, but it is the sort of colour which would express the warmth of a dying fire rather than a conflagration. It must be soft and soothing, mellow and, above all, express a quiet and peaceful ambience.

All these determinants of intensity and subtlety require a practised understanding of colour fixing and the resultant ability to mix quickly and effectively the colour to suit the occasion. Effective darks, for example, can only be achieved with pure pigment, with little or no inclusion of white. Equally, true light areas need an untouched background, where a clean mix can be applied of white with a little Winsor lemon, by cadmium red or viridian, included so as to suit the occurring light effect and its bias, be it towards coolness or warmth.

KEY

Consideration of the key in which to set the painting is necessary to convey the mood of the day. As with photography, we can play around with exposure to create an over-exposed/high-key or under-exposed/low-key result, thus accentuating drama or, alternatively, lending an ethereal quality. Drawing out these added values can increase the interest of what might otherwise be an average subject.

Over the course of time I have noticed how my paintings, and those of colleagues, have, unwittingly, altered in key from time to time. A number of years ago I went through a phase of producing rather high-key works, some of which I now find unacceptable to the eye. It seemed the norm at the time, and it is somewhat strange to

SHOWER CLOUDS OVER PORT HENDERSON
Oil on canvas, 14×10in (35×25cm)

think my eye accepted this. It took a colleague to comment, when viewing a series of paintings in the studio, that 'These seem rather pale, compared to a few years ago', thus giving me the jolt I very much needed in order to reassess the key in which to pitch my future efforts. Essentially, I had not noticed the gradual lightening of my palette – I had obviously been taking the close-toned and ethereal quality much too far.

Often, of course, in the search for a punchy, dramatic effect, it is a good idea to pitch the whole canvas in a low key (a little darker than the eye appears to record), in this way allowing a successful emphasis to be placed on any light notes and areas which may occur. The higher the key, the less the tonal contrast, and to maximise an effect in this case, an emphasis on the careful matching of tonal blocks relative to and in harmony with each other is a definite advantage. *The Easter Camp* illustrates this point.

COUNTERPOINT

As the painter gradually becomes familiar with the many techniques and, dare I say, 'tricks' of the trade, he or she can then draw on these to enhance the character of the work. Counterpoint – the illusion of an object appearing dark against a light area, and the reverse – is used to effect a feel of three dimensions. Perhaps the most obvious example, familiar to all, is the observation of a vertical feature such as a telegraph pole against the sky. It appears quite dark and seems suddenly to become lighter as it reaches shapes at building height and below. But the 'illusion' creates a very definite space beyond itself and the building shapes, and generates a most useful painterly asset for a convincing rendering of the qualities of depth and recession.

The phenomenon is evident everywhere to a lesser or greater extent, and is a major factor in shape delineation in all paintings. In fact an awareness of counterpoint, otherwise known as counterchange, is probably the most important single prerequisite in the making of any painting

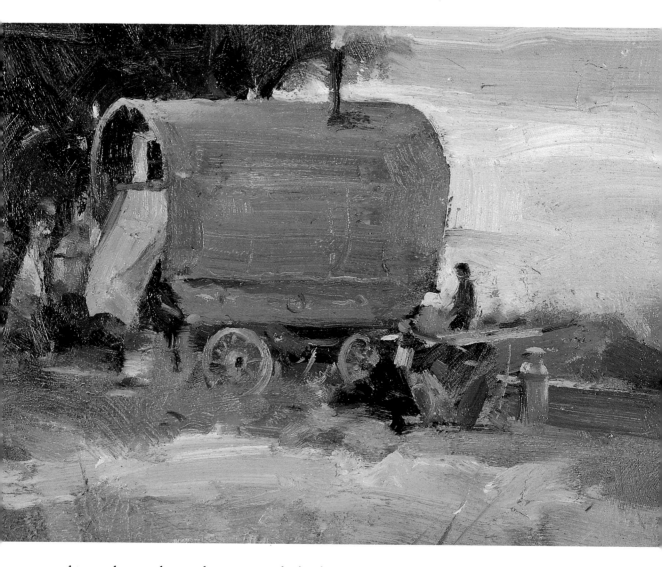

and is much in evidence when viewing the landscape. *Home for Six* depicts a 'cameo' of a single gypsy caravan at its winter quarters, surrounded by the trappings of that particular lifestyle, in which a very clear effect of counterpoint can be observed. The caravan roof is seen just as I have outlined it – dark against the sky, and fading to a lighter tone as it comes under the influence of the tree form; and you will notice other more minor and subtle instances of the effect in the painting. It is a good exercise to search these out; in fact, try it for all the reproductions in the book.

LOST-AND-FOUND EDGES

Turning now to the overall shape of an object or area within the canvas, it may seem acceptable to the inexperienced eye to interpret it with the edge firmed up all around the shape. However,

HOME FOR SIX
Oil on board, 10×7in (25×17cm)
A mother, father and four children live in this caravan all the year round – a more polite and charming group of children one could not hope to meet. This was the second of two paintings produced in the area of the encampment on the same day. Quite often the later painting of the day, produced with a more carefree spirit, can yield the more successful result. Certainly, I feel it was the case here.
Home for Six *took some forty-five minutes and was never touched after leaving the location.*

this tends to isolate the shape and cause a flatness of effect, such that the object does not appear in context or unity with the shape adjacent to it. To 'lose and find' those edges, as they do in fact appear in nature, helps firstly to establish this unity, and secondly to secure an illusion of three-dimensional quality in the object or shape itself. Essentially, the losing and finding process is a whole series of subtle counterchanges, often on a very small scale.

OFF THE ROAD TO BRACORA
Oil on board, 20×24in (49×60cm)

TIMING

The timing of the application of certain passages can be instrumental in the eventual outcome of a piece of work. A common pitfall is the application of dark areas over a previously painted light area (the most common example is the sky) before the under-painting is dry. This process will never work, and the applied darks will always lack density. When applying a dark mass which is known to be alongside a lighter section, paint the dark mass over a dry, toned surface with no white inclusion. Then go for the light area, loaded with body colour and largely matching up to, but not excessively cutting into, the dark area abutting it. In this way a crispness of application will be achieved and the result is infinitely more convincing than the 'creamy', uncontrollable result achieved with the first method. Remember the important maxim, *light into dark, but never dark into light.*

RIGGER STROKES

A most useful, but regularly avoided, sub-technique is the use of the fine, superimposed line – the rigger stroke. The sure application of this needs a high level of confidence, especially when on site. Carrying a fine line through previously painted areas can, if unsuccessful, mean the repainting of quite an expanse, and can destroy the confidence needed for its restatement. Here, it can be worth waiting for the canvas to dry, recording the line in the studio at a later time from a note in the sketchbook.

The most convincing application, though, is if the necessary boldness can be drawn upon on location, when the line will appear less intense and dense. In addition, by dragging a little of the underpaint along with the fine stroke, the line

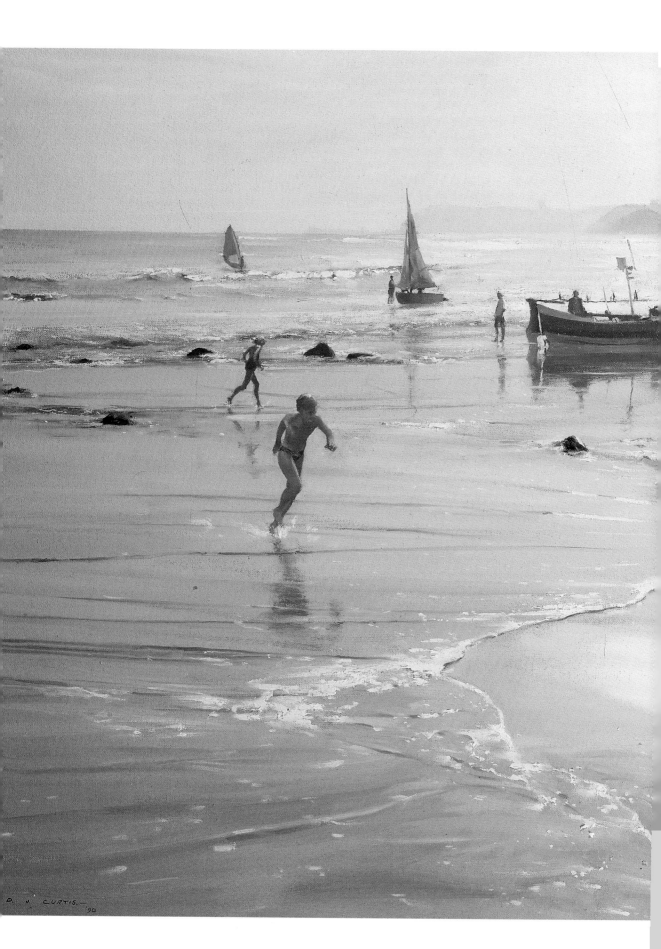

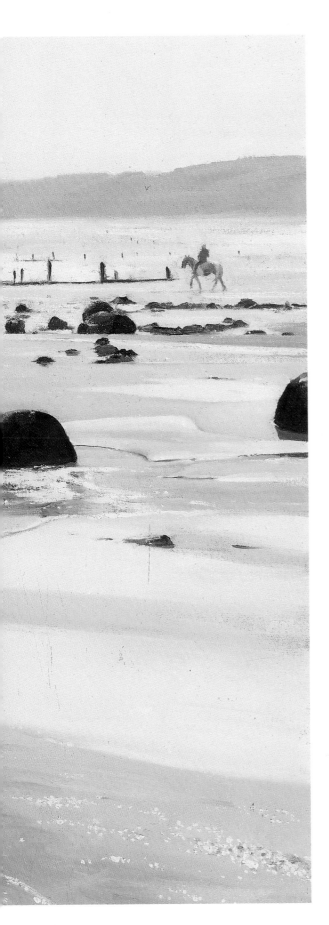

will inevitably appear to be 'married' more closely to the structure. The sort of lines one would expect to produce in this way are, for example, the finer tracery of tree branches, and the rigging and anchor lines of boats and shipping.

Until recently, a part-worn No 1 short, flat bristle was my preferred tool for the job, but the recent introduction of the acrylic rigger, again of a short, flat type, has given us a very sensitive, textured brush which is well adapted to this demanding work. When attempting rigger strokes, the sensitivity of the result is directly related to the hold on the brush. This should be very light indeed, almost to the point where the brush could easily be dropped, and it is the weight of the brush alone which transmits the line, using the side edge and with a minimum of paint on the point.

USING A CAMERA

Nowadays, the ready-made subject is becoming more and more elusive as the 'modernisation' of the land everywhere continues apace. Farmland devoid of hedgerows, the loss of our noblest trees each time severe gales occur, the general 'tidying up' of our countryside, cities and towns – all these are reducing the store of appealing subjects upon which we can draw. There is a tendency, therefore, for the painter to search out the more localised composition and 'go in close', even to paint the outdoor still life. Garden studies abound, as do paintings of allotments, parks, and anything and everything to do with the population at leisure. With these themes, there follows the inevitable inclusion of the figure. I am pleased to say that this element is not only forming a key feature in the work of the professional, as always, but is also tending to be used more extensively within the landscape by the amateur painter.

In days gone by, when life was led at a slower pace, the artist would often formulate his compositions working entirely out of doors, employing local inhabitants as his models. These set-piece paintings, whilst being carried through technically to a considerable degree of finish still retained a feeling for having been produced in the open. Often the sitter would be asked to sit for long periods over several days, and notable

THE EARLY MORNING SWIM, SANDSEND
Oil on canvas, 30×24in (74×60cm)

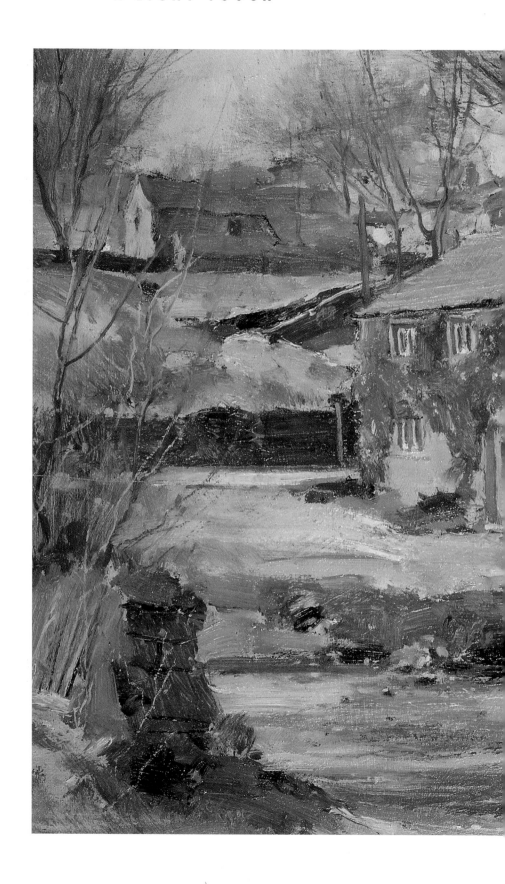

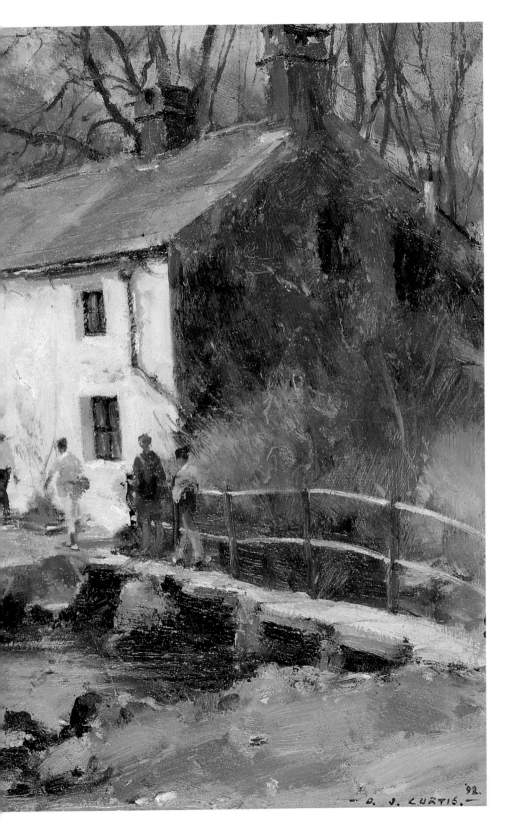

A CORNER OF MALHAM
Oil on board, 16×20in (39×49cm)
This subject had the benefit of sound compositional values
with an effective 'lead-in', areas of sharp contrast and good
solid shapes, giving an overall simplicity to the piece.

groups such as the Newlyn school would employ this principle, resulting in the many fine works by familiar names like Alexander Stanhope Forbes, Walter Langley and Henry Scott Tuke, amongst others, who would produce canvases where maybe one or two figures dominated the subject area. The results were often low-key, close-toned pieces, very carefully executed to create a realistic image but retaining a 'painterly' feeling of utmost integrity.

In today's high-pressure world, where time is at a premium, the 35mm camera – that convenient sketchbook – takes the place of the sketchbook, creating an immediate 'frozen' image. One wonders if, in the days before photography, had the painters of that time been blessed with this facility would they have used it? I think to some extent they might.

In conversation with a painter friend recently, the subject of the integrity (or otherwise) of the use of the camera was raised. He felt that the demands on the professional in meeting exhibition schedules and commission commitments were now so intense that some degree of photographic reference was inevitable, if only to save time. Having had a lifetime's painting experience out of doors, however, he felt he had established a technique sufficiently formidable as to be able to interpret, from the photographic image only, the information that was necessary to make a statement in the usual 'immediate'

WILD FLOWERS AND SARAH, MANOIR DE LUSSAC
Oil on board, 16×12in (39×30cm)

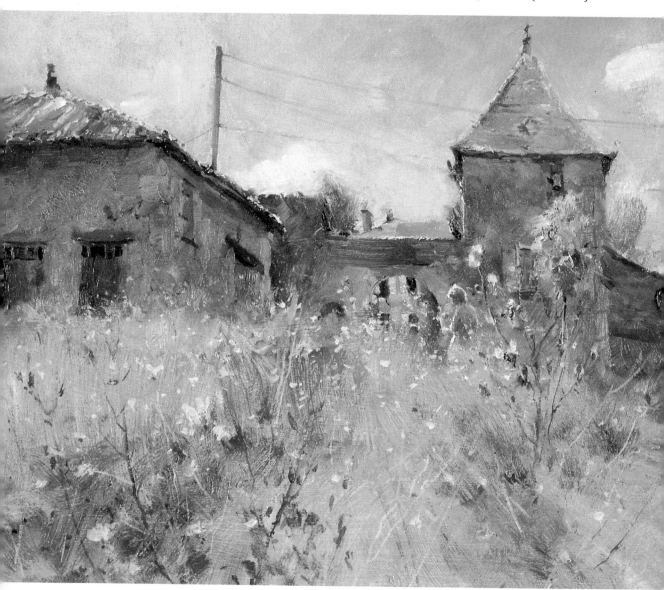

OLD WILLOWS, MISSON
Oil on board, 10×8in (25×20cm)

style of utmost economy of form. When comparing his finished work done on the spot and that using the camera reference, he believed it was not possible to distinguish any difference in approach.

This may be fine for the seasoned artist, but the amateur and leisure painter tends to record the camera's image slavishly, to the extent that it is a faithful reproduction but says little of the character at the other end of the brush. In addition, the camera tends to record the image in a flat plane, and this lack of recession is inevitably transferred to the canvas. Oddly, a painting pro-duced from a series of rough sketches and colour notes can often say a lot more, due to the fact that just sufficient to tell the story was recorded, and is consequently transferred as such to the canvas.

Maybe there is scope for all these facilities, if they are used with discretion; at the end of the day, it is the result which matters, regardless of how it was achieved.

STEP-BY-STEP DEMONSTRATION

ART IN ACTION

This demonstration was a studio undertaking, derived from various line drawings and oil sketches, plus photographic reference, which were produced on site during an arts festival held in the summer. As one of many official demonstrators for the four-day event, my task, along with other colleagues, was to re-enact a studio setting in a large marquee and work as one would normally on a day-to-day basis, at the same time answering the public's questions about technique, procedure and so on. In this situation, one had to work largely from detailed sketches and colour notes.

As the first day progressed, I gradually became fascinated by the activity outside our tent area and resolved to record some impression of the wonderful atmosphere pervading the whole event at some point during the four days. Groups of figures in summer attire, seen against a backdrop of the various marquees bathed in the mid-summer sun, was vintage material for me. This demonstration piece was typical of the possibilities which existed.

STAGE 1

From all the information I had gathered, it was possible to arrange a group of figures in various poses to provide a balanced feel of the activity in this outdoor café area. Of course, the image was not seen on the day as it appears presented on canvas here. The great benefit of the studio setting is that it offers a degree of detachment from the subject, as well as the freedom from the urgency imposed by a painting time limit which is experienced on site. As a result, there is time for reflection – that freedom to move various elements of composition around a bit which is so necessary for the larger, more considered 'grand design'.

As might be expected, the best of the subject potential appeared when viewed into the light and the composition reflects this. Having decided on the arrangement of the elements in sketch form, I selected a 30×24in (74×60cm)

stretched canvas, primed and already washed with a raw sienna and ultramarine wash, which was left to dry completely.

At this initial stage, it seemed that the breakdown of the composition was probably into four distinct elements. A backdrop of mid-distant tree forms acted as a foil to the simple, strong shapes of the two marquees. Punctuating this form were the figure groupings, some receiving edge lighting – that lovely effect only achieved in backlit conditions such as these. Finally, there was the complex arrangement of tables and chairs and the resultant cast shadows, providing that strong design element of hard-edged shape and form.

With this in mind, a top edge for the marquee roof line was suggested. Above this, a broad indication of the tree area was blocked in using french ultramarine, raw sienna and viridian (no white added), with a little cadmium orange in certain areas to indicate a diffused light source emanating through the gaps in the structure.

It is a sound idea to attempt to produce the paint strokes as one would when faced with an outdoor situation – that is, in a loose, broad manner. Technique can tend to 'tighten up' in the studio situation if one is not careful. With the same mid-dark tonal weight as the tree section, the figure groups were then broadly indicated, with local colour intensity added where necessary. All structural blocks and masses for the café furniture were suggested at this time, flowing down from the figure placings. Knitting together these last two elements seemed to set the scene for the lightest shapes and forms, some of which appeared as light passages totally encapsulated within a darker surround – shapes within shapes, with extremes of tonal shift.

The only mass which included titanium white was the surface texture of the marquees. The variable, cool blue-grey shadow tones of this section provided an ideal separator for the tree and figure sections. The predominant blue considered for the mix was ceruleum, with sugges-

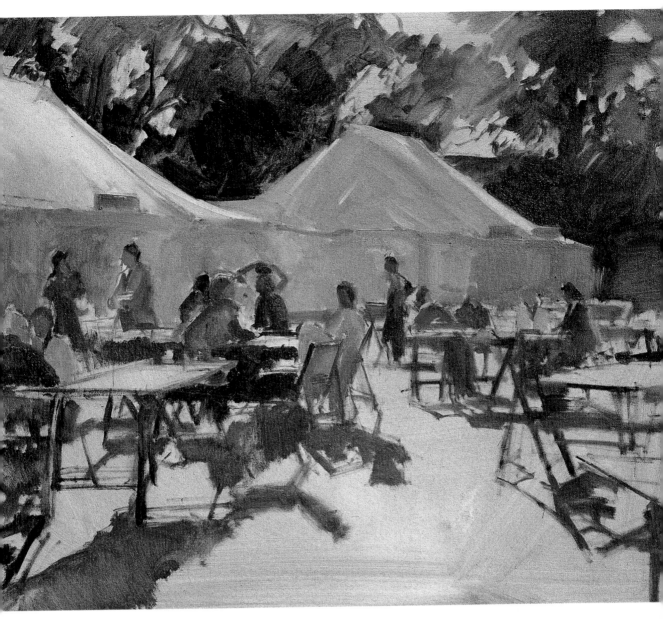

STAGE 1

tions of cadmium orange and cobalt violet in the warmer reaches, ie those receiving reflected light.

With these main statements placed, I could stand back from the canvas and consider the general feel of the composition and whether any adjustments seemed necessary. With the transference of relatively minimal information from various sources, and working from a small to a much larger scale, difficulty can often be experienced in placing the elements in the correct scale and proportion to one another. In this case, I had to consider carefully the relative size of each figure or group as they appeared next to or in front of their near neighbours.

STAGE 2

The initial visual impact when viewing this subject for the first time had undoubtedly been the intensity of the light table-top surfaces. The placing of those 'diamond' shapes, marching through the composition, appeared to be the key design element.

At this stage it was important to establish these surfaces as the lightest light, using pure titanium white with a little cadmium lemon. To enhance the shine or glow of the surface, a suggestion of cadmium orange was placed along the edges which appeared to receive the maximum amount of light. This move needs to be carried out with considerable subtlety but, if

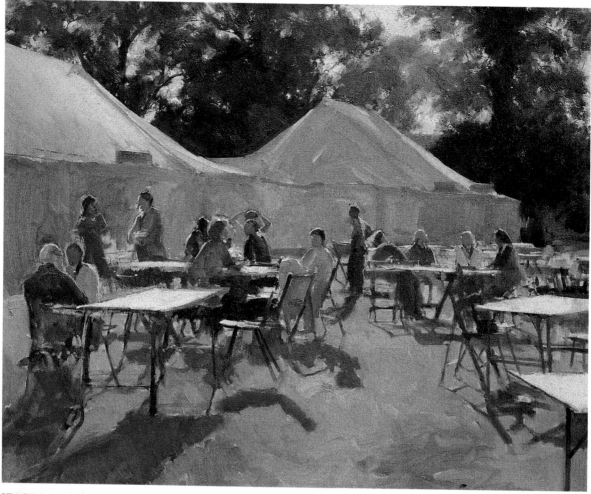

STAGE 2

at all successful, the effect is immediate and sur-prisingly convincing. Here, it also helped to soften the interaction of the three adjoining edges – the extreme light, the orange edge and the surrounding dark tone – thus adding to the desired diffused illusion.

The grassed area was next to be blocked in, its tonal value relative to the extreme light tone just applied to the table surfaces. An indication of the shadow tone struck from the tables, chairs and figures, in accord with the grass surface re-ceiving sunlight, was then suggested.

All the canvas surface area had now received some semblance of colour and tone cover, and the best plan was to work down again from the top to the bottom of the canvas. I turned my attention once again to the backcloth of tree shapes. Resolving the lost and found edges, creating the variations in tonal weight and giving further consideration to the filtered, diffused light through the centre section, involved an intense and absorbing period of concentration. It

was, in fact, one of those times when one be-comes totally unaware of the actual act of paint-ing, the flow of absorbed unity with the subject transcending any practical awareness of the craft of painting.

The completion of this section established a top edge to the two marquees and was the final Stage 2 working.

STAGE 3

This stage was concentrated entirely on the central plane of the canvas. It involved the subtle observation of the marquee structures and the play of light on the various surfaces, this backcloth setting the scene for the superimposi-tion of the various figures. The pitch of tone for the marquee needed to be sufficiently low in key to allow the light catching the figures to have enough impact. These highlights would then create a separation and a feeling of space, and assist the transition of the eye through the scene.

A continuation of the diffused light effect,

aimed for in the tree section, had to be borne in mind as the marquees were dealt with. Essentially, there were three sharp, pointed shapes receiving maximum light. (In a way, it helps to resolve areas of shape and form in this simple format, and forget for a moment what an object or shape actually is. Once it is stated, the tone or area next to it can be matched to suit. Eventually, by continuing the process, the totality of the shape or area is achieved.) Various folds or creases in the material were resolved in a simplified manner, contrasting with the effect of the taut, stretched material of the roof sections. Suggestions of the tent poles and guy ropes served as interesting minor echoes of some of the strong directional lines seen in the foreground passages.

Now for the figures. Seen largely in silhouette, they needed to be painted quite simply in a bold and unfussy manner. In many cases, the edge lighting was enough to create a feeling of three dimensions without having to resort to any further resolution of form. It was important, though, that the individual light edges were the correct tonal version of the actual area of colour. For example, the central, standing, mid-distant figure was given a very definite, high-key viridian highlight, compared with, say, the nearer standing male figure in the fawn jacket, whose lit edge is the correct light tonal variation of the parent colour.

Allowing just a little more detail for the elderly gentleman in the near foreground helped

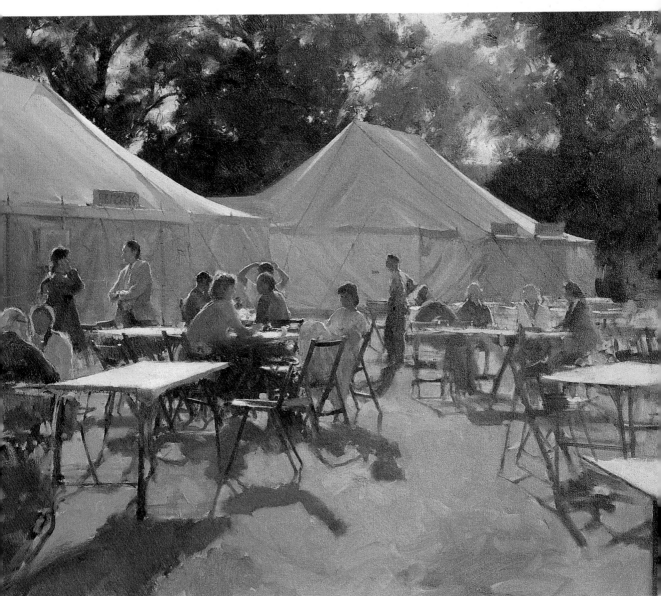

STAGE 3

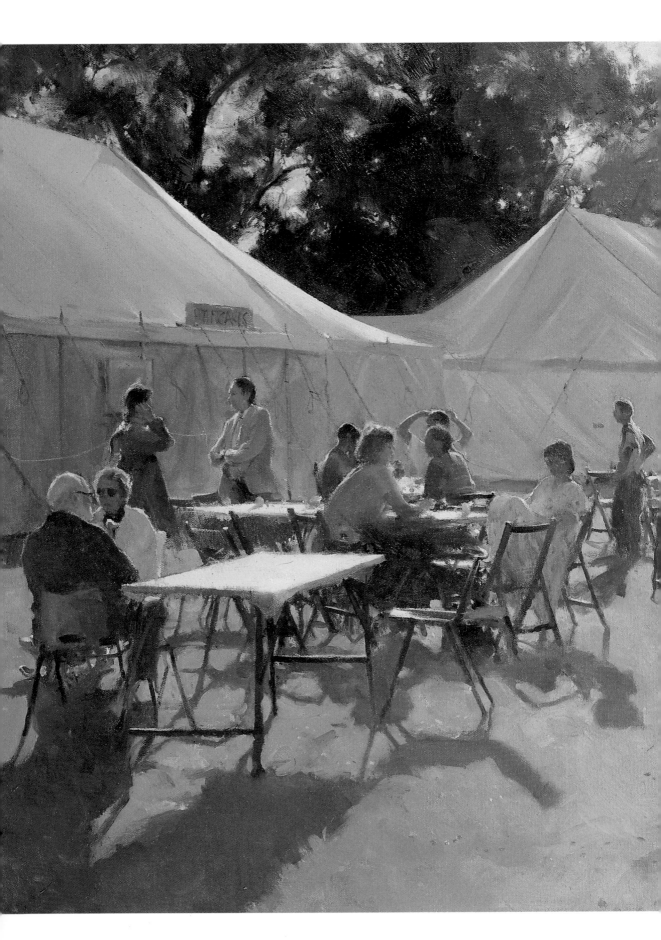

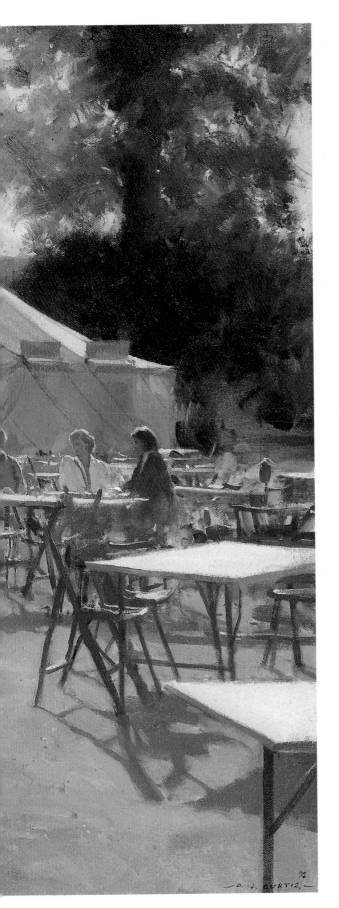

to draw the eye forward and, of course, gave a feeling of perspective, as the relative detail was less stated as the figures receded into the middle distance. The stances and attitudes of the various groups and individuals were considered carefully, as I mentioned in Stage 1; at this point I also attempted to add further indications of the character of each.

STAGE 4

Having now secured the first three elements in, hopefully, a correct register one to another, the task at this stage was to unify the complete scene by the further resolution of the complexity of the cafe furniture. A convincing interpretation of this would assist the attitudes and stances of the figures, and also generate a contrast of shape and texture to the simplicity of the upper sections. This was the stage I was looking forward to least of all: resolving the tracery of all those converging lines in a convincing, uncluttered way would be no easy task.

I opted for the bold approach, simplifying when appropriate and forcing those lines which offered the greatest contribution to the effect of good design. It did, of course, mean leaving out a lot of linework which actually appeared in the image on site. Some nice highlights on chair seats and so on were also observed and stated, these forming an ideal linking motif to the highlights on the figures.

With the sun appearing in a more or less central line on the canvas, the shadows tended to emanate slightly to the left and right of centre. This was a useful observation, and enabled the composition in the lower section to strike a sort of inverted 'V' form, settling or leading towards the standing figure right of centre. This figure then constituted the focal point of the whole work. The 'V' form was then repeated in the line of the roof of the more distant marquee. Once again, repeating links or motifs come into play.

Finally, what outdoor café scene is complete without the odd chaffinch or sparrow in attendance? I included one or two – in this case, they simply served to punctuate a large, simple area.

STAGE 4

CHAPTER FIVE

BACK IN THE STUDIO

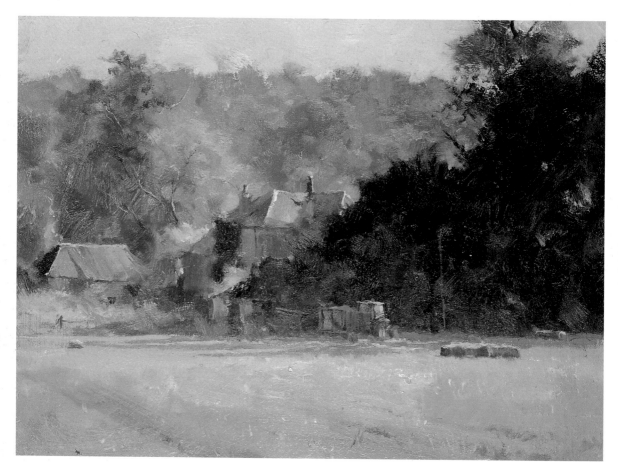

HARVESTING, SANDBECK
Oil on board, 16×12in (39×30cm)

When gathering material, it is a sound policy for the landscape painter to try to resolve the chosen image into a simple form. This important discipline, stemming from the initial approach phases (as suggested in the early stages of each step-by-step) discussed earlier, should be kept in mind throughout the execution of the painting to avoid an over-fussy or photographic representation of the whole. There is no image with more vitality than the boldly observed, vigorously produced work painted from the soul! Perhaps a measure of the success or otherwise of the exercise lies in the 'snap' decisions regarding subject placing, tone and colour balance taken in that early stage.

IN THE STUDIO

However, when the day's efforts are transported back to the studio, often what seemed reasonable back on site can be bitterly disappointing when viewed inside, divorced from the subject. The strokes appear rough and unresolved and the subject, though immensely appealing at the time, proves to be now not all it was cracked up to be. On the other hand, that piece of work which seemed an abject failure on site might just, once popped in a frame, be not such a bad

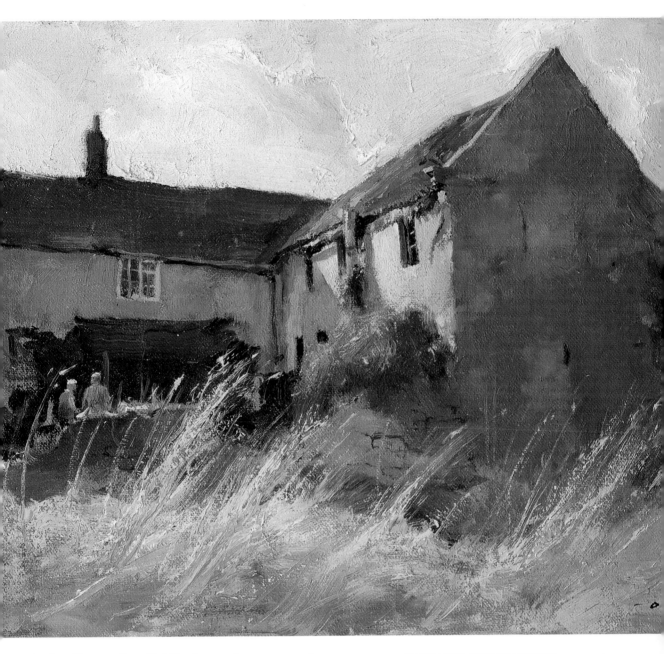

COTTAGES, KIRK BRAMWITH
Oil on board, 14×10in (35×25cm)

little offering after all. Whichever the emotional response, it is a good move to place the work out of sight for a few days, and allow all the pigments to dry off. One reason for work looking distinctly worse on the evening following the day's painting is that, because of differing pigment mixes, all the areas are drying out at different rates and affecting the visual relation and pitch of one area to another.

After two or three days, look at the painting again – you may get a pleasant surprise! In any event, a resolving period – tidying up the loose ends, as it were – is probably all that is needed to secure a success. Occasionally, it can be quite extraordinary when, after perhaps half an hour or so's considered reappraisal of the piece, probably not overpainting much but merely giving attention to obvious shortcomings, there suddenly appears a result beyond one's wildest expectations. On the other hand, sadly there is always that work which one had great hopes for and from which, when back in the studio, no amount of persuasion with a brush will yield a satisfactory result. You just have to face it – some you pleasantly and surprisingly win, others are destined for the scrap heap. (By the way, old paintings on board make excellent fire lighters!)

ADDING FIGURES

Within the security of the four walls of the studio, away from the rigours of the outdoors and all distractions, one is able to concentrate the mind wonderfully. Here, it is possible to glean a lot from the original outdoor piece and maybe extract that additional quality by adding figures, enabling the painting to live a little more.

Figures can be stated quite loosely – some painters, over the course of time, develop a sort of shorthand in the process. This may be seen as simply one flick of the brush for the body, the legs gradually diffusing with less definition as the feet appear not actually to meet the ground. This 'trick' gives the illusion of a figure in movement. Just a single spot of tone is positioned for the head. All this may sound a bit slick, and indeed it can be, so caution needs to be exercised lest with repetition the method becomes too much like a recipe. Because, after some practice, it becomes a surety for effect, the painter can cease to observe the actual figures as they might appear in life and resort instead to this assumed safe option. There may be a case here for the occasional use of the camera, if some particularly interesting figure or group should come into view. Once again, though, the real purist would argue that if you have the skill and technique you should be capable of securing the image in paint on site anyway. It is this determinant of skill which will, in fact, 'sort the men from the boys'.

USING A SKETCHBOOK

It is a valuable exercise to try to produce studio paintings from your sketchbook. Based upon the old adage, 'What you can't remember of the subject away from it, doesn't matter', the discipline of a memory exercise supported merely by linework and colour notes does yield surprisingly honest, bold and un-fussy paintings. Try also working up oil sketches from previously produced watercolours. The switch of medium is very refreshing, and can only serve to enhance the depth of understanding of this complex and elusive art form.

FINISHING TOUCHES

Once the painting is completely dry, it is time for a final reassessment of its merit. Sometimes it is worth considering adding the occasional 'glazed' area over passages which might just require a

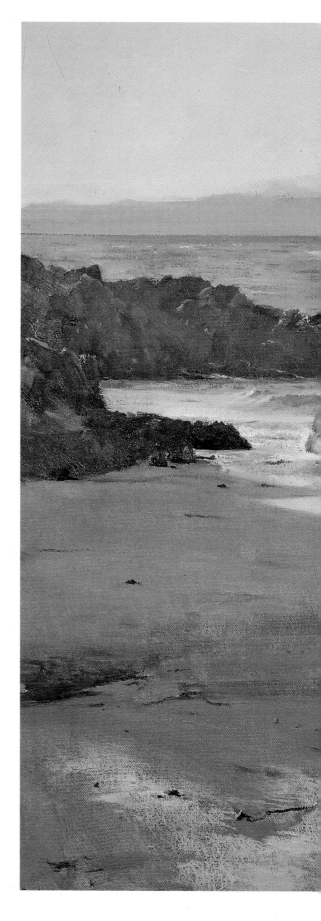

ARISAIG
Oil on canvas, 30×24in (74×60cm)

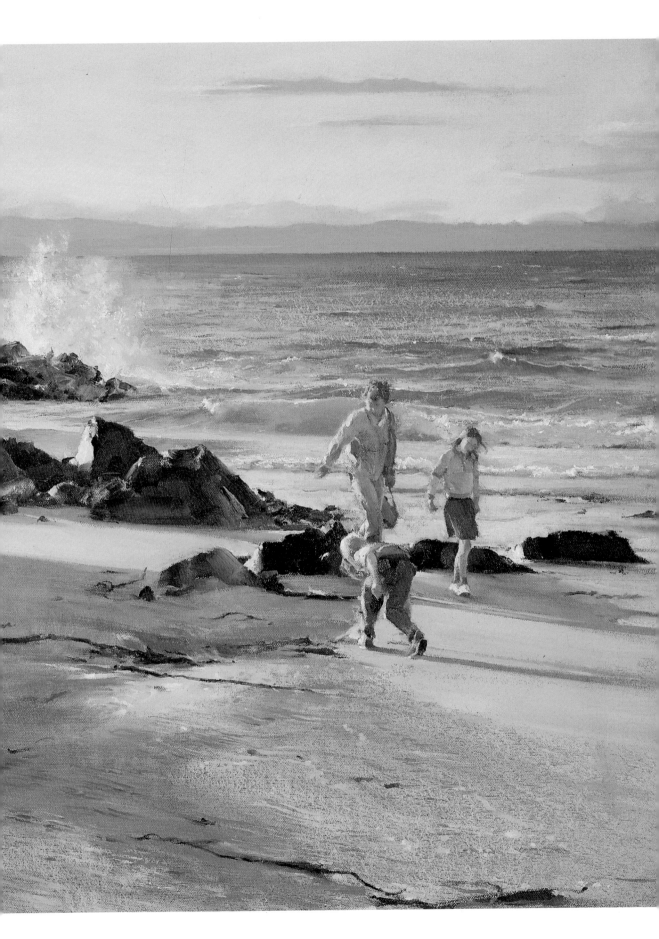

TOBOGGANING, HARWELL
Oil on board, 16×12in (39×30cm)

degree more unity. I find a wash of retouching varnish with a pure pigment mix of, say, transparent gold ochre and french ultramarine, with a little permanent magenta for any warmer areas, has an effect somewhat similar to the technique of that unifying wash used in the final stages of a watercolour. The pigments must be carefully chosen from those which contain no body colour, for the desired effect is one of transparency, with the original brushwork remaining dominant. The wash must be very fluid in application and give but a tentative suggestion of unity.

For exhibition purposes, I would in any event advocate a coat of retouching varnish applied a month or so after completion of the painting. The application should be effective for about three to four years and has the benefit of livening up those dulled passages caused by the paint sinking into a slightly porous surface.

EXHIBITING

At all levels there is a fervent wish to exhibit the results of one's labours. These days, numerous gallery and open exhibition outlets are available to all-comers. Perhaps the best indicator of the painter's progress comes through submitting to the various open exhibitions and national art competitions run by the major art societies.

The selection process is very severe, and to have a piece accepted is an accolade indeed for the amateur. It is by no means certain that the 'professional's' work will pass the judges' scrutiny either. It can be a tough business, and a broad back is needed for the inevitable disappointments. On the other hand, I have witnessed the sheer elation of amateur friends of mine when their work is accepted. I shall never forget my first acceptances by the Royal Society of Marine Artists many years ago – I walked on air for a fortnight.

It is very frustrating for the painter to do the rounds of the gallery circuit in an effort to market his or her work, and meet with rejection at every call. Whilst the commercial galleries are always on the lookout for fresh talent, they do have exhibition commitments, often two or so years in advance, and can rarely find a slot at short notice. However, most dealers do as a matter of course attend the major open exhibitions to search out potential exhibitors, thus reinforcing the need, if one is at all ambitious, to submit to these prestigious shows.

THE ROAD MENDERS
Oil on canvas, 14×10in (35×25cm)

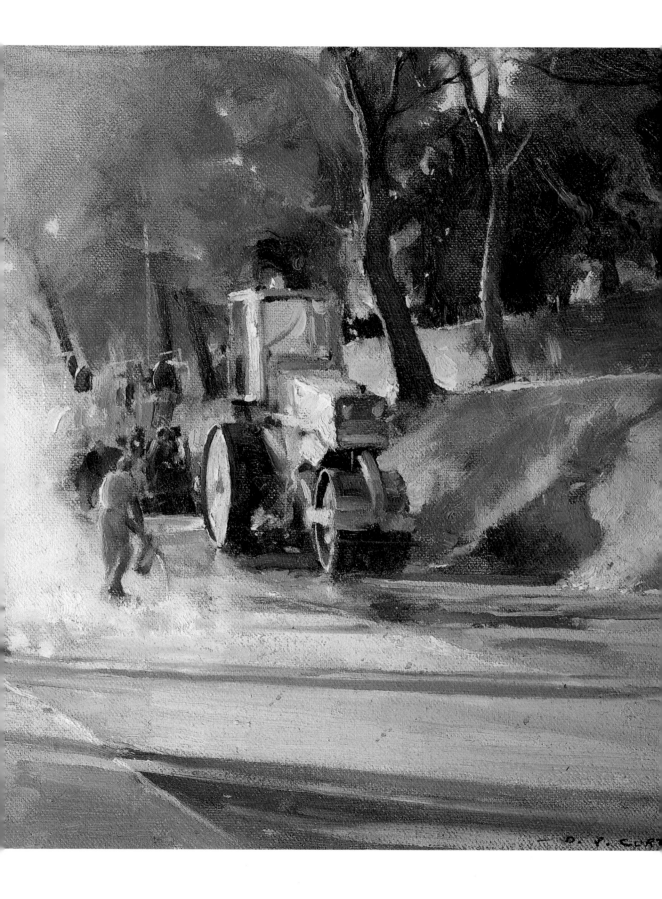

TREES AND STREAM, ROCHE VALLEY
Oil on board, 8×6in (20×15cm)

Should the painter be content to set his or her sights a little lower, he can join the local art society and experience the pleasure of painting with companions, as well as the thrill of having work exhibited at the annual show. A degree of selectivity is usually necessary, but invariably all members are assured of at least one showing on the walls.

FRAMING

To show a piece of work off to its best advantage, the frame surrounding the image is most important. The frame should not compete with the painting but should gently isolate it from its surroundings and draw the eye to it. Generally, I would recommend a moulding of generous proportions, and include an inner slip-moulding at all times.

I am fortunate in having a picture framer close at hand who, being a painter himself, has a very sympathetic eye as to what may suit the individual painting. He will take the untreated plain moulding and then subject it to a whole series of built-up underlays, gradually gearing the finish to accord with the character of the image. The various built-up treatments are then carefully recorded and coded in readiness for repeat orders, and are geared to a full range of variable moulding sections and an extensive range of finishes of both warm and cool bias. Framers prepared to undertake this custom-made approach are a rare breed, and deserve the extensive trade and loyal patronage that they can generate.

LEISURE PAINTING

Painting for pleasure is recognised as being one of the fastest-growing of all leisure activities. Many more people of retirement age are now picking up the threads of a pastime they can dimly remember having enjoyed in early life. Some soldier on, just enjoying the therapy of moving the paint around the canvas – and why not? But occasionally some special talent emerges, and it is the responsibility of the tutor to nurture this and encourage a continuity of effort.

As mentioned in Chapter 3, the overseas painting holiday is also becoming increasingly popular, bringing another vision of the landscape to the painter's eye. It is always visually stimulating to experience the landscape and light of another land, from the regular haunts of the artist to more obscure destinations, and exhibitions are certainly enhanced by the inclusion of a foreign content.

On the other hand, it is not an uncommon experience to be less than satisfied with the efforts that are produced when abroad. Sometimes the visual 'kick' is so overwhelming, and the work rate so frenetic, that you think you are not effectively recording sufficient of the place. The results, when viewed in the hotel bedroom, look dire. I remember this happening on a visit to Venice. On the first day I had produced three small paintings which, on viewing away from the subject that same evening, were on the face of it quite disappointing. As the week progressed and I became more familiar with the surroundings, I gained a better understanding of the place and consequently became more 'in tune', and the later work visually said more about the area.

Once the week's efforts are transported

FROM LYTHE BANK
Oil on board, 10×14in (25×35cm)

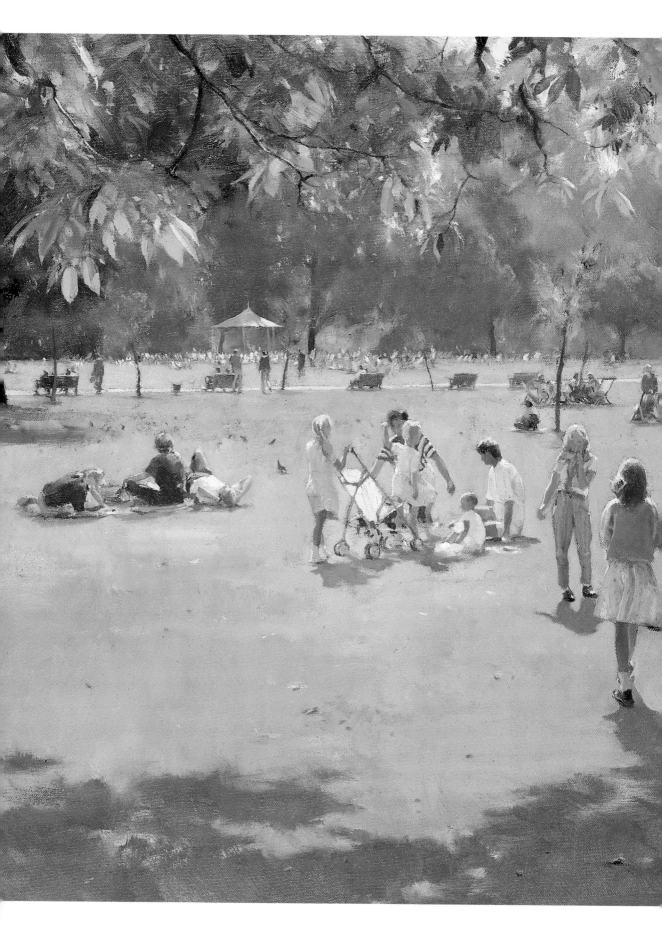

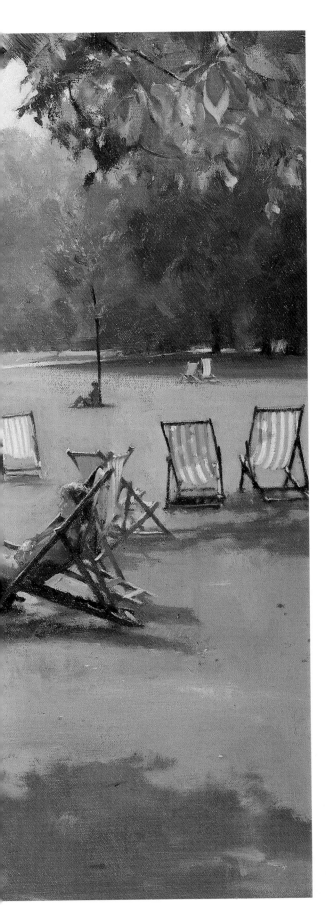

home, there is that rather pleasant period of reassessment, where one by one each painting is reworked to a greater or lesser extent – and, with any luck, you might just end up with some material of exhibition quality.

THE ARTIST

Self-criticism is a vital component in the make-up of the painter. As soon as you become complacent about the standard reached, there will be no marked ongoing improvement in your work. Painting, with all its pitfalls and disappointments, requires an immense amount of staying power in order to retain the necessary degree of enthusiasm. This can wax and wane in the early days, but with luck the odd successful result will increase confidence and trigger a surge of activity. It is consistent effort which undoubtedly reaps rewards.

Once you have discovered the language of oil paint, and gained sufficient expertise to convey a message or feeling about a subject, you will have a facility firmly established which will enrich the lives of your audience and become a joy for life for you the painter.

Finally, I would like to give a few markers which encapsulate much of what has been said or illustrated in these pages.

- Study books illustrating the work of professional artists, and try to work out what it is about a painting that appeals. In landscapes, look at the position chosen for the horizon, the shadows which define the form, and so on. Is it a cool or a warm painting overall? Is it painted on a high or a low key? Attempt to imagine what the painting looked like in the early stages of production.

- Try to establish at least one vertical and one horizontal, and their relationship within the limits of the canvas.

- Hold the brush well back from the ferrule so that it (and the hand) does not obscure the work. For much of the painting, hold the brush as one would a knife when buttering bread.

TOWARDS THE BANDSTAND, ST JAMES PARK
Oil on canvas, 30×24in (74×60cm)

- Learn to 'live' with the painting in the build-up stages: creativity is sometimes a long business involving constant adjustments and reappraisal.

- Don't be despondent about what you feel to be lack of progress. Good painting is not a happy accident or a matter of luck – it is the product of experience and many apparent failures.

- An 'unsuccessful' painting can be the basis of a new painting. Simply scrape off any 'knobs' of colour, turn the old painting upside down on the easel, make one or two construction lines or marks to represent the new subject and carry on – the result may surprise you!

- Take every opportunity to visit as many art galleries as possible. On returning home, try to remember the work or works which appealed most. Flex the memory and make a thumbnail sketch – then revisit the gallery for a richer experience.

- And lastly, practise, practise, practise – either drawing or painting, or preferably both. The more that is done, the easier it becomes: it is an enjoyable struggle, so keep at it in spite of the results. Gain confidence but not complacency through your successes.

BARN STUDY ABOVE HATHERSAGE
Oil on board, 16×12in (39×30cm)

STEP-BY-STEP DEMONSTRATION
FIFTH AVENUE

On a hot, sultry afternoon, I sat as unobtrusively as possible on Fifth Avenue in New York, painting this view with the little *pochade* box. The picture size was a mere 8×6in (20×15cm). This demonstration took the basis of this study and expanded upon it, adding where appropriate odd figures and points of interest.

The height of the New York skyscrapers ensures that many Avenue subjects like this will have large sections in deep shadow down to road level. Any features of particular interest can often be set ideally against this dark backdrop, as indeed was the case here. The ice-cream vendor on the sidewalk became the ideal focus for the painting, his umbrella in sharp contrast to the dark void beyond.

STAGE 1

The whole key to this work is that of dramatic tonal contrast. It is therefore important to state that weight of tone without reticence in the first instance. With a 16×12in (39×30cm) Gesso and texture-paste primed board, I immediately laid in an overall wash of burnt sienna and french ultramarine, allowing the wash some real weight of tone around the central section on the board and thus establishing that feel of depth straight

away. With a clean rag, some strategic lighter elements were erased in an attempt to surround the dark nucleus with these lighter facets. These included the light block on the right-hand side and the essence of the building on the left. This now set the scene.

I then proceeded to break up the dark shape with the punctuations of the traffic lights and pole, the ice-cream vendor's umbrella, and a suggestion of vehicles and some figures crossing the roadway. These were all very loosely stated, as I wanted to try to capture the same feel as in the little painting but on this larger scale, transmitting a sense of it also having been produced on site.

STAGE 2

In order to establish a feel for perspective and

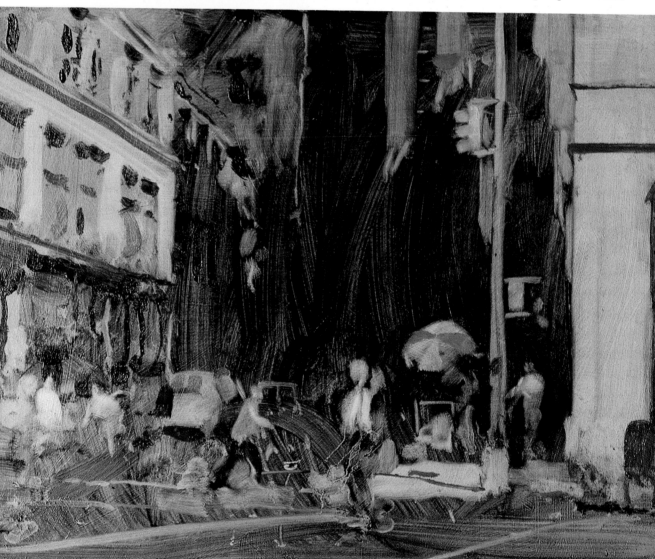

STAGE 2

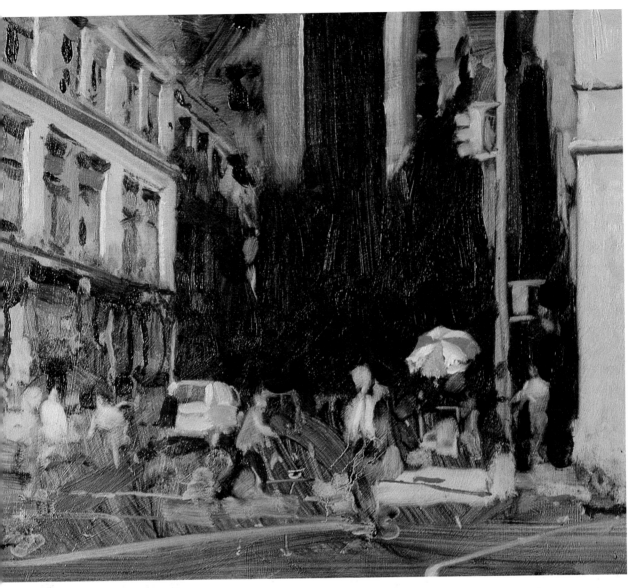

STAGE 3

height, some constructional lines and positioning marks were now suggested, still using the french ultramarine and burnt sienna base mix. This included extracting some structure on the left-hand side building frontage, and the relatively simple details on the right-hand side block. A few further indications of figurative movement were also necessary at this stage, so surrounding the whole of the central dark mass with form and activity.

A few colour notes, those of particular tonal contrast, were stated at this stage, including the yellow traffic lights appearing against the darkness behind. The umbrella was also treated with an indication of its local colour value, along with one or two darker notes using a cooler, bluer mix of colour. This indicator of blue was then re-

mixed in a higher key to continue the theme by painting in a narrow band of sky tone, the proportion of sky showing being just sufficient to cause a separation or relief to the overall warmth of tone of the piece. On location, when assessing the final stance for this painting I had felt that this indicator of sky was just sufficient. Moving further left, of course, revealed a considerable expanse of sky, but the subject then appeared rather too obvious in composition and with much too uniform a distribution of shapes.

Even at this point, the bustle of city life should have been emerging. Care and discipline would have to be exercised from now on, in order not to allow too much tightening up of the brushwork to take place, such that the spontaneity evaporated away.

STAGE 3

Now many of the basic parameters were in place, it was time once again to force the central dark, shadowed portion. With a good solid mix of french ultramarine and burnt sienna, and with raw sienna and ceruleum included in certain slightly cooler passages, the shapes were then restated, working around and so intensifying the lightest elements appearing against this dark mass.

At the opposite end of the scale of tone, the extremes of light were observed and indicated: that is, the white sections of the umbrella, the rear of the white van and some edges of the first and second-storey windows of the left-hand side building. A light tone for the right-hand building edge was applied using titanium white, Naples yellow and a tiny hint of cadmium red, to give a little warmth in places to this stated area.

The solidity and firmness of structure of the whole painting was now becoming evident.

STAGE 4

This stage addressed many of the other intricacies of the main body of the painting above road level. There was a need to observe the modelling of each building section, firming up the impression by the addition of crisp light notes and passages, and ensuring the whole work began to 'knit' together.

Some nice reflected light was seen deep in the darkest central area and was restated. The vertical pole carrying the traffic lights was positively painted in, with due attention given to its local colour value.

Once the whole of this upper section had received sufficient working, consideration could be given to the foreground. I felt it needed to be treated quite simply, merely providing a base to cushion the complexity of the structures above. Pitching the road surface as a mid-grey tone with just a suggestion of the lines in the road seemed a good base from which to overplay any figurative inclusion reserved for the development of the final stage.

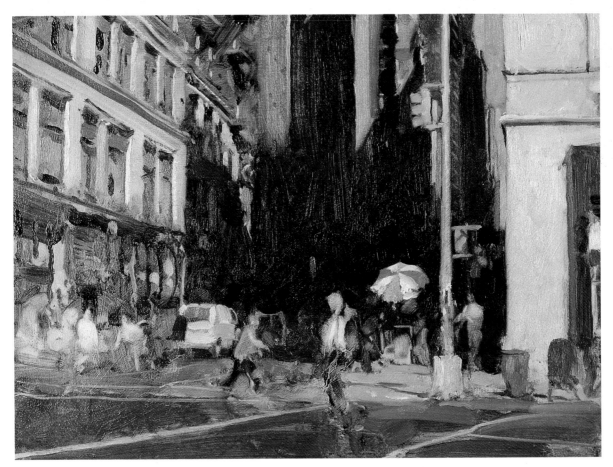

STAGE 4

STAGE 5

Back in Stage 1, a few indicators of where figures might be suitably placed had been hinted at with the rub-out process. Some adjustment now took place to bring out each figure's size relative to the others in the scene. Working from left to right, I originally had the extreme left-hand figure rather larger than in its final assessment. For it to be of the same size as the main figure, just right of centre, drew the eye neither to one nor the other; in other words, each was competing for interest. The left-hand group were deliberately given light shirts to enable them to be more effective against a darker background, while the figure crossing from left to right enjoyed the obvious counterchange of light to dark and the reverse. The ice-cream vendor rang the change, having more colourful clothing. A good, light figure between the pole and the edge of the right-hand building broke up the dark mass, leaving · the extreme right-hand figure, with relatively dark clothing, purposefully understated. The main accent was placed on the large central figure, which is in such a position as to be a part of a sense of several strong, vertical accents around this centre section.

Attention was then given to the white van, recording it in a little more detail. It was in an important position, helping to continue the encapsulation of the dark mass with varied objects of interest receiving sunlight.

The whole painting was completed in about two hours. I started out with a view to a speedy interpretation of this image, and the result I think captures that essential feeling of spontaneity.

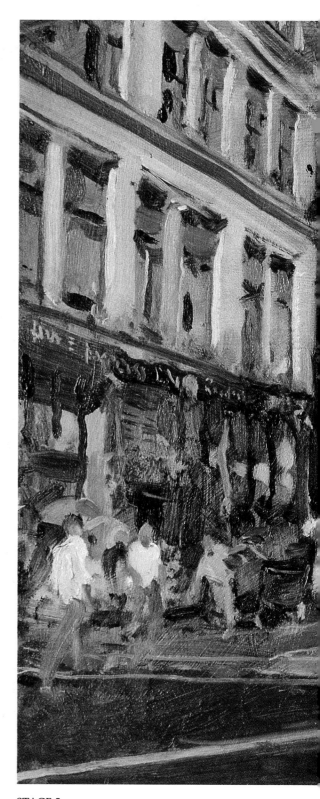

STAGE 5

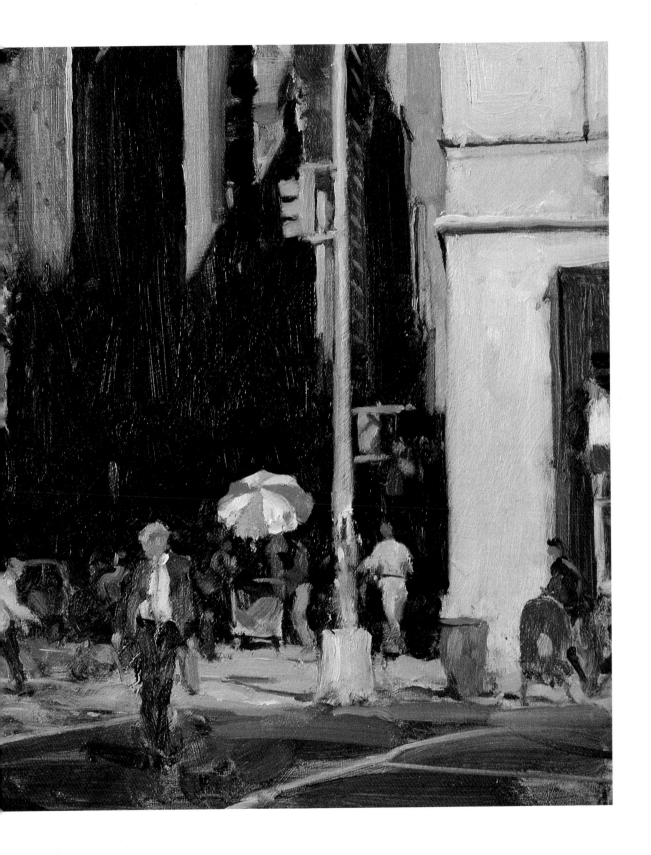

INDEX